KNOT THREAD STITCH

Exploring Creativity through

Embroidery and Mixed Media

LISA SOLOMON

© 2012 by Quarry Books
Text © 2012 Lisa Solomon

First published in the United States of America in 2012 by
Quarry Books, a member of
Quayside Publishing Group
100 Cummings Center
Suite 406-L
Beverly, Massachusetts 01915-6101
Telephone: (978) 282-9590
Fax: (978) 283-2742
www.quarrybooks.com
Visit www.Craftside.Typepad.com for a behind-the-scenes peek at our crafty world!

10 9 8 7 6 5 4 3 2 1

ISBN: 978-1-59253-772-3

Digital edition published in 2012
eISBN: 978-1-61058-414-2

Library of Congress Cataloging-in-Publication Data
Solomon, Lisa.
 Knot thread stitch : exploring creativity through embroidery and mixed media /
Lisa Solomon.
 p. cm.
 Summary: "Knot Thread Stitch presents a modern, experimental, and creative ap-
proach to thread and embroidery projects. You'll find fun and surprising project ideas,
a unique artistic approach, and unconventional mixed-media materials such as stamps,
paint, sequins, paper, and shrinky dinks. These projects are designed to be quick, fun,
abstract, and creative, and many offer clever ideas for personal customization. With
easy-to-follow steps and project variations, this book also includes project contribu-
tions and embroidery patterns from a long and stellar list of renowned artists and
bloggers, including Lisa Congdon, Camilla Engman, Heather Smith Jones, and Amy
Karol, just to name a few"-- Provided by publisher.
 ISBN 978-1-59253-772-3 (pbk.)
 1. Embroidery. 2. Mixed media (Art) I. Title.
 TT770.S687 2012
 746.44--dc23

 2011050179

Cover Image: Andrew Paynter
Photography: Andrew Paynter, except as noted in the Photo Credits on page 144.

Tech editor: Marla Stefanelli
Cross stitch diagrams and stitch guide illustrations: Marla Stefanelli
All other templates courtesy of respective project designers

Printed in China

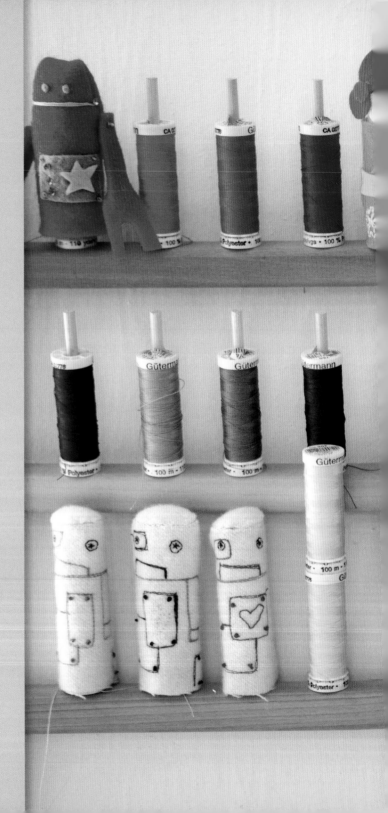

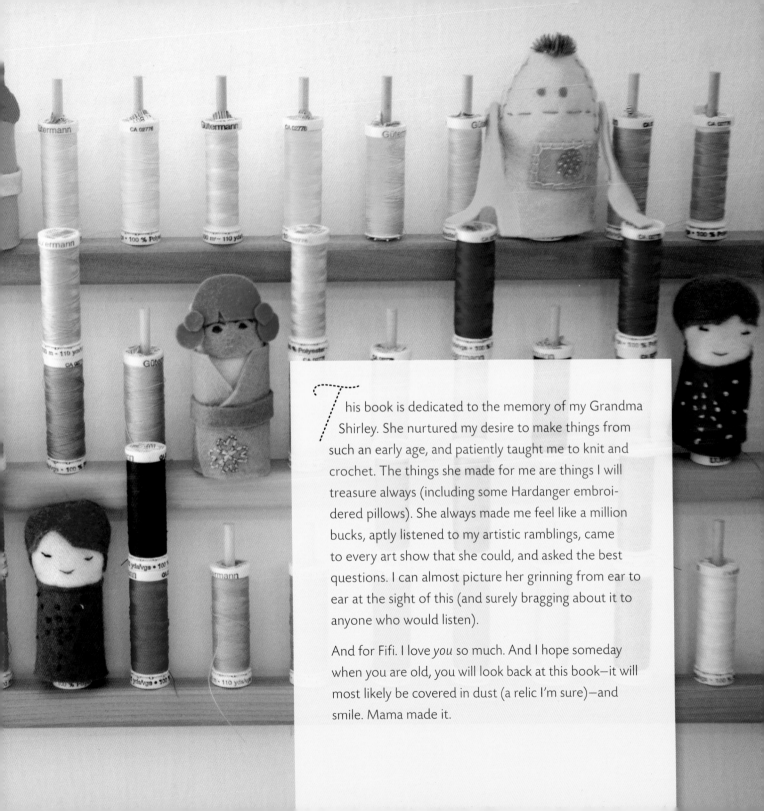

This book is dedicated to the memory of my Grandma Shirley. She nurtured my desire to make things from such an early age, and patiently taught me to knit and crochet. The things she made for me are things I will treasure always (including some Hardanger embroidered pillows). She always made me feel like a million bucks, aptly listened to my artistic ramblings, came to every art show that she could, and asked the best questions. I can almost picture her grinning from ear to ear at the sight of this (and surely bragging about it to anyone who would listen).

And for Fifi. I love *you* so much. And I hope someday when you are old, you will look back at this book—it will most likely be covered in dust (a relic I'm sure)—and smile. Mama made it.

CONTENTS

Introduction .. 7

CHAPTER ONE
LET'S START 9

Fabric ... 10

Thread ... 13

Tools .. 16

Transfer Methods 101 20

CHAPTER TWO
MAKE STUFF 27

PROJECT 1: Tea Towels

Part 1: Wipe and Dry Towels with
a Sycamore Pod Pattern 29

Part 2: Hand-Embroidered Golden
Sycamore Pods on a Printed Tea Towel 32

Artist Version: Eat, Drink, and Clean
with lettering by Kate Bingaman Burt 34

PROJECT 2: Pillowcases

Part 1: Sleeping on Clouds 37

Artist Version: Arrow Pillowcase
by Martha McQuade 38

PROJECT 3: Handkerchiefs

Part 1: Fight that Cold! 41

Artist Version: Embroidered Scales and
He Loves Me Hankies by Blair C. Stocker. 42

Artist Version: Updated Monograms
by Blair C. Stocker 44

PROJECT 4: Contemporary Sashiko

Part 1: Fireworks Skirt 47

Artist Version: Simple Coasters
by Sally J. Shim 49

PROJECT 5: Inspired Silhouettes

Part 1: Willy Nilly Stitched Cat and House 51

Artist Version: Floral Silhouette Pillow
by Lisa Congdon 54

PROJECT 6: Monogram Patches

Part 1: Shaggy Red Cross and Initial 57

PROJECT 7: Drawing with Thread

Part 1: Poppy Pods 61

PROJECT 8: Children as Muses

Part 1: Multi-eyed Monster Tote Bag 65

Artist Version: Portrait of Papa by Amy Karol
and Delia Jean Matern 68

PROJECT 9: Hand-Carved Stamp Designs

Part 1: Iron Apron 71

Artist Version: Leaf-stamp Card
by Patricia Zapata 74

PROJECT 10: 3D Mending

Part 1: Pom-Pom Scarf 77

PROJECT 11: Portraits

Part 1: "Me and Gram" Photo-Based Portrait 81

Artist Version: Illustrative Portraits
by Betsy Thompson 84

PROJECT 12: Pet Portraits

Part 1: Wilfredo 87

Artist Version: Morran Pillow
by Camilla Engman 90

PROJECT 13: Fabric-covered Buttons

Part 1: Button Buttons 93

Artist Version: Fruit and Veggie Cross-stitch
by Frosted Pumpkin Stitchery 95

PROJECT 14: Shrink and Stitch It!

Part 1: Hexagon Necklace 97

Artist Version: Lion and Birdie Zipper
Pulls and Key Chains with illustrations by
Susie Ghahremani 99

PROJECT 15: Modern Commemorative Samplers

Part 1: On This Date 103

Artist Version: "66 Years"
by Heather Smith Jones 106

PROJECT 16: T-shirts

Part 1: Austin American Tee 109

Artist Version: Birds in the Sky and Let's Go
Fly a Kite T-shirts by Christine Castro Hughes 112

PROJECT 17: Felt Finger Puppets

Part 1: Handy the Robot and Sakura Kokeshi 115

Artist Version: Digit and Aiko
by Wendy Crabb 118

CHAPTER THREE
FIND INSPIRATION 120

Templates 128

Stitch Guide 136

Contributing Artists & Resources 140

About the Author 142

Acknowledgments 143

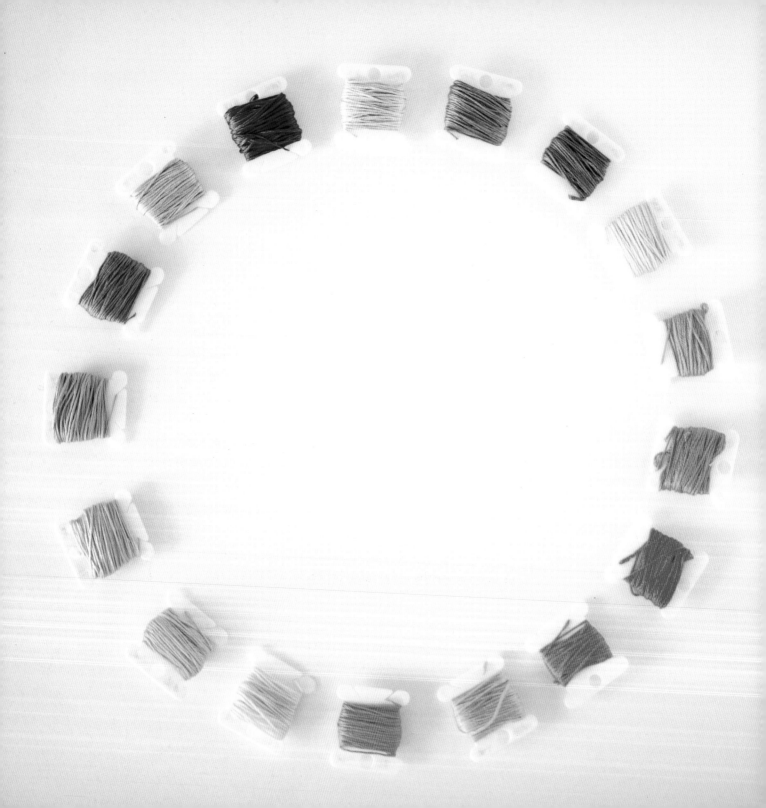

INTRODUCTION

To embroider you need just a few things: fabric (or another surface), needle, thread, and time (and maybe an embroidery hoop). But don't be fooled by this seemingly simple formula; combining these choices in many different ways will result in entirely different outcomes.

I came to embroidery later in life, although I like to claim that it's in my blood. My grandmother was an avid needlesmith, creating amazing needlepoint and Hardanger (a traditional Norwegian embroidery technique where threads are counted, embroidered, cut, and then more embroidery added). I decided to pick up embroidery after reading *The Subversive Stitch* by Rozsika Parker in graduate school. I found that stitching added texture and depth to my artwork that I couldn't duplicate using other materials. As I researched and learned stitches (one by one) I loved the intimacy and the meditative effect embroidery offered.

Part of the appeal of embroidery is its familiarity. Fabric and thread are an essential part of our lives. All of our clothing is stitched together. Even if you've never sewn a hem, you own garments that use them. And maybe you have ventured to replace a button when it has fallen off. That familiarity can bring comfort. It can also spur us to challenge the conventions of needles and thread and see to what new heights we can take them.

Embroidery is an act of decoration as well, and we are naturally drawn to decorating and personalizing the things that surround us. In my artwork I constantly explore how to use different media together for interesting effects. I hope this book will inspire you to mix techniques and media to create hand-crafted pieces that are meaningful to you.

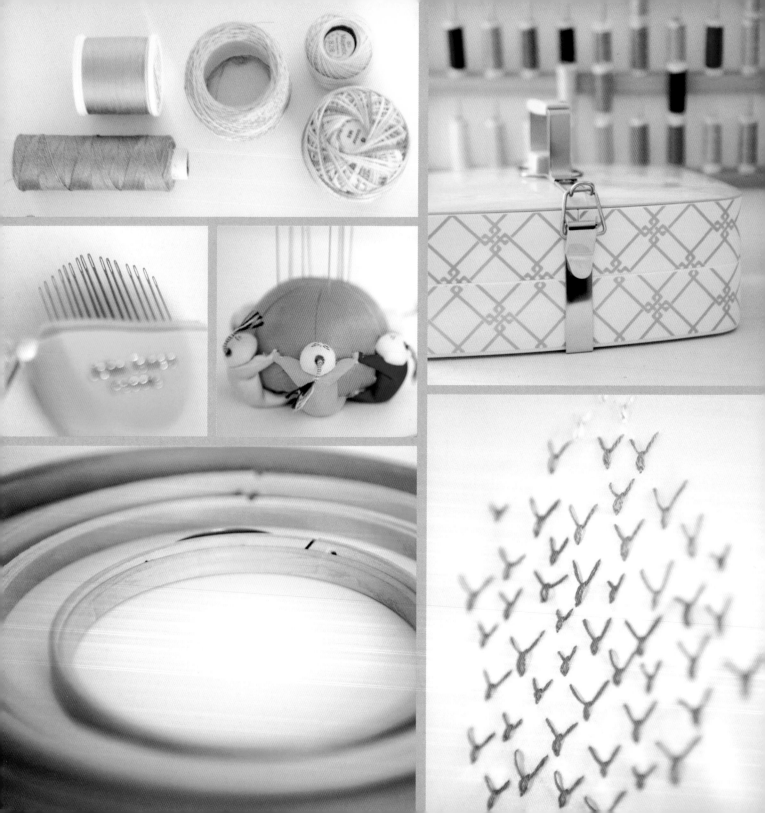

CHAPTER ONE
LET'S START

If you are a crafter of any kind, you probably have everything you need to start embroidering. If you are like me, you might have bags of embroidery supplies that you picked up at a flea market or were passed down to you. I love learning about tools and supplies and their uses. When you know how things are supposed to work, you can use them properly or use them in new creative ways (know the rules before you bend and break them).

In this chapter you'll find information on the basic embroidery materials—the types of threads and fabrics you can use and tools you might need and how they work. Your materials are important choices that reflect what kind of maker you are. Each choice, however small, will invariably affect the mood and look of your finished piece.

The "Transfer Methods 101" section offers some methods to generate and transfer artwork. While by no means comprehensive (transferring could be the subject of a whole book in itself), I offer my own "greatest hits" of transferring methods. Let's get started, shall we?

FABRIC

Traditionally, embroidery has been stitched onto evenly woven linen (such as Lugana, Jobelan, and Evenweave linen) and cotton block weaves (which are cotton threads woven together to create clearly defined holes at the corners of each block). Types of cotton-block fabrics include Aida, Hardanger, Oslo, and Annabelle cross-stitch. The weave of cotton-block fabrics helps you place your stitches to make a more regular cross-stitch or needlepoint design. I humbly suggest that you can embroider on just about any fabric; however, when choosing fabric, keep a few things in mind.

The weight of your project: Choose a fabric that will support the amount of thread and stitching you will have. Test to see if the thread on the underside will show through to the front of your project; if it does, are you okay with that? The fabric also needs to be able to withstand the thread pulling through it. Assess the type of stitching you will be performing—are you making simple stitches or elaborate and dense stitches? Complex designs that require a lot passes through the fabric will need a sturdier fabric to support them.

The appearance of your project: Do you want a finished result that looks matte and dull? You should use 100 percent cotton or linen fabric. If you want something shiny, select silk, velvet, or a polyester blend for the background. Matte fabrics are traditionally used to complement a busy pattern, while shiny fabrics accent contrasts. However, you should feel free to break tradition where you see fit.

The weave of your chosen fabric: Looser weaves tend to be better when using thicker threads (thinner threads might disappear in the fabric), and tighter weaves work best with thinner threads. Some tighter weaves will work with larger threads but may pose more of a challenge—thick threads are difficult to pull through without causing distortion or possibly tearing the fabric. If you are unsure, test the stitch on the fabric. Also keep in mind that some things that are considered "wrong" actually generate interesting effects.

PREPARATION

If you are going to wash the completed project, I recommend preshrinking your fabric before embroidering on it. Otherwise you can end up with unintended puckers and wrinkles (although sometimes puckered results look primitive and cool, so feel free to turn this into a technique if you wish!). If you don't want to preshrink your fabric, then hand-wash your project in cool water and air dry, or dry-clean when they need laundering.

Not all projects in this book are stitched on fabric. I happen to like the results of embroidering on paper. If you can punch, drill, or make holes of some kind in a surface and then pull a needle and thread through the holes, you are embroidering. There is no end to the surfaces you can use as long as you have the right equipment. You can embroider watercolor paper, vellum, wood, even ceramics.

To poke pilot holes (preliminary holes that will give you a line to follow) in paper, I suggest a sharp pushpin or needle and a self-healing cutting mat or corkboard. Lay your paper flat on the cutting mat and punch holes along the line you will embroider. Then take your needle and thread and follow the path you created. Keep in mind that the closer your holes are to one another, the smaller and tighter your stitches will be.

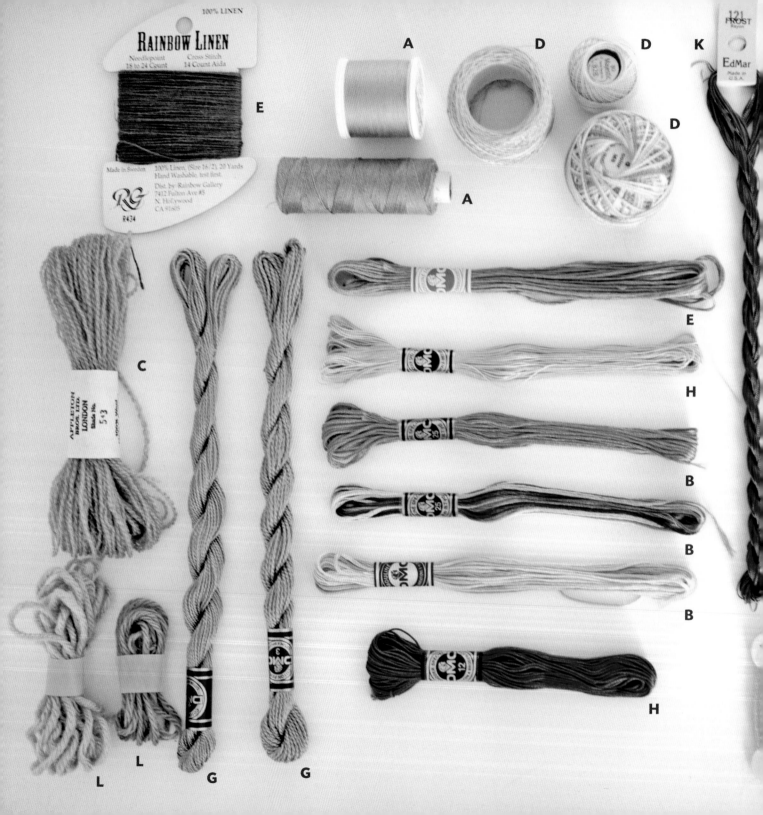

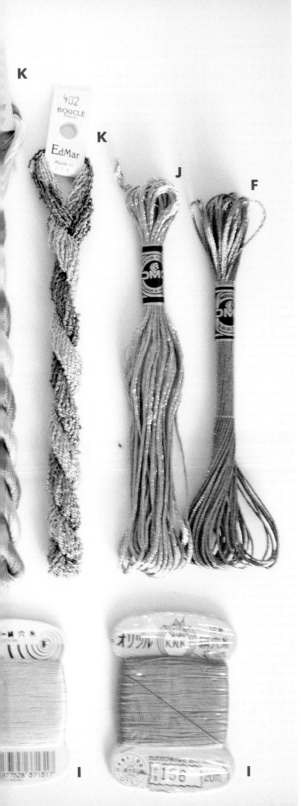

THREAD

There are hundreds of colors of embroidery floss made by a variety of manufacturers—I've spent more time than I'd like to admit to choosing between twenty shades of green. Pick the thread color you think will be the best for your project. Also think about what may or may not be practical. A very thick wool yarn probably won't work well with a delicate silk fabric, but then again it might just turn out great—take the plunge.

The thread you choose will make a difference in how your project turns out. The same stitch will look entirely different in pearl cotton than in a metallic thread or a wool yarn. Some embroidery flosses are twisted and can't be divided, while others can be separated to single strands, which work well for delicate stitching (and don't be afraid to use regular sewing-machine thread for ultra-delicate stitches). Keep in mind that thicker or plush threads could overwhelm your design, and are difficult when sewing delicate lines and sharp turns.

I tend to use 6" to 12" (15 to 30.5 cm) of thread length when hand sewing. If you are sewing with a single thread, cut the thread about 18" (46 cm) long, thread the needle, and tie a knot in one end.

If you are sewing with a doubled thread, cut the thread 18" to 24" (46 to 61 cm) long, thread the needle, and knot the ends together. Consider how much stitching there is and how long a thread you can manage. Longer threads can knot and tangle easily. Embroidery thread is more delicate than all-purpose thread; a long thread will be worn out by the time you get to the end. You will see a marked difference when you start a fresh thread—it's worth the extra time to use a shorter thread.

Traditionally, embroidery does not use knots to start and stop the stitching. Knots can cause bumps on the right side of your project. I tend to like knots because they are easy, and a quilter's knot (see page 137) works the best for me. When I don't want knots, I leave about 1½" (4 cm) of thread loose at the beginning and then go back and weave the thread in and out through the back of the stitching once it's completed. Alternately, you can secure your thread using a few small backstitches, hiding the stitches under previous work, or catching the threads on the back of the weave when you start and stop.

ALL-PURPOSE SEWING THREAD (A)

This thread is generally used when sewing projects together by hand or machine. I also use it to embroider delicate lines or fine details.

COTTON EMBROIDERY FLOSS (B)

This thread is very common and is found in practically every fabric and craft store. Some brands look and feel cheaper, and other brands look and feel opulent. Cotton embroidery floss has a slightly shiny appearance and is made up of six strands that you can divide to get your desired thickness (double strand, triple strand, etc.).

TIP When dividing floss, cut a length of floss (really long sections are hard to separate; it tends to tangle as you pull it apart). Begin at one end and pull the desired number of threads away from the strand. I find slowly pulling out and down from the strand will allow the floss to untwist as you pull. Pull the other threads slightly in the opposite direction.

CREWEL YARN (C)

This thicker thread is made from wool and has a duller appearance than silk or cotton threads. It is great for freestyle folk patterns or crewelwork. For more texture, use several strands together.

CROCHET COTTON (D)

This thread is twisted (can't be separated into individual strands), comes in various thicknesses, and is available in a variety of colors. It's my go-to thread when I want the look of cotton, a thick outline, or I have a lot of space to fill.

LINEN EMBROIDERY FLOSS (E)

This thread is similar to cotton embroidery floss, but is made of linen, which gives it a matte finish. Some people claim it gives their work a rustic look.

METALLIC EMBROIDERY FLOSS (F)

This sparkly metallic floss is also made up of six strands that can be divided. It comes in glow-in-the-dark or opalescent versions. These newer threads have been tested to be colorfast and tarnish resistant.

PEARL COTTON (G)

This tightly twisted thread generally has more luster than standard embroidery floss. It comes in three weights (from light to heavy: 3, 5, 8). You cannot divide this thread into strands.

SOFT COTTON EMBROIDERY FLOSS (H)

This twisted thread is similar to pearl cotton, but without the luster. It is made from long staple threads and has a soft feel.

SILK (I) AND RAYON FLOSS (J)

Silk and rayon threads are much shinier than other threads and have a very distinct look and feel. The sheen intensifies the colors, making them appear richer than the same shades found in cotton threads. These are available in skeins that are divisible or as twisted threads. Silk tends to be more expensive and isn't as wearable as cotton embroidery floss as it generally needs to be dry-cleaned.

SPECIALTY THREADS (K)

Anything that will fit through a needle is fair game for embroidery. There are a host of threads and yarns to try—yarn with small textured nibs, ribbon, or variegated yarn and floss. The variety is endless and you can mix and match your threads to create any number of results.

YARN (L)

Any scrap yarn is a great substitute for crewel yarn. Yarn will fill in a lot of space quickly, to create a thicker texture than regular embroidery thread. Keep in mind that the type of yarn will yield different results. A thin cashmere will look very different than a silk cotton or super fluffy wool.

TOOLS

The tools included here are used in almost every project in this book. Other tools that are specific to a project are included in that project's material list.

EMBROIDERY HOOPS

Oh the types of hoops you can find! They come in all sizes of circles and ovals, wood, metal, and plastic in candy colors. The really large hoops are used for quilting and aren't recommended for embroidery. Also don't use old hoops that have dust, dirt, or oils on them, as the grime will transfer to your fabric.

Hoops help keep your fabric taut, which leads to more even and neat stitches. That said, you can embroider without a hoop—you just have to take

care not to pull your stitches too tight, which will cause your work to pucker (unless you are going for that puckered look). Also, hoops don't work for certain surfaces such as paper.

To use a hoop, select a size a little larger than your design area. Place your fabric right side up over the inner ring, loosen the screw of the outer ring, and place it over the fabric and inner ring; tighten the screw. Pull the fabric taut, working around the hoop to ensure that the fabric weave remains straight. If necessary, tighten the screw a bit more. Don't overtighten the screw, as that can pull on the warp of your fabric and cause distortion when your stitching is complete.

Some hoops don't come with a tightening device. If you need to tighten your hoop more so your fabric doesn't slip, wrap some bias tape or fabric strips around the inner ring.

> **TIP** Keep your hoops in a clean box with a lid when not in use.

EMBROIDERY NEEDLES

While not necessary, it can be useful to purchase some embroidery, crewel, or chenille needles with sharp points, because the eyes are generally larger than regular sewing needles and are easier to thread. Blunt embroidery needles are referred to as tapestry or darning needles and work well with thicker thread and canvas.

Needles come graded in size from fine (high numbers) to coarse (low numbers). Select a needle with a diameter similar to the thread you're using. The needle will create the hole the thread will pass through, and eliminate excessive wear on the thread.

Needles for sashiko, a traditional Japanese embroidery technique, are about 2" (5 cm) long and are uniform in diameter from the eye to the tip. To do sashiko properly, you need a longer needle, but you can substitute a doll needle.

FLOSS BOBBINS

Amanda from Frosted Pumpkin Stitchery ("Fabric-covered Buttons" on page 97) introduced me to the bobbins (shown above) made from heavy cardstock or plastic. Prior to using them, I had a tub full of completely unorganized and often tangled embroidery floss. Now when I use a skein for the first time, I wind the remainder around a bobbin, and then write the color number, brand, and dye lot on the top in case I ever need to match it. Now my floss is organized. I can easily pull the bobbins for a project, and put them on a notebook ring to keep them together.

IRON

Use an iron set at a moderately high heat to press your fabric before and after embroidery. If you use a transfer pen, test to be sure the ink can be removed once it has been pressed. If not, remove the ink before pressing the completed project.

When ironing your embroidery, place the project facedown, and use a press cloth between the fabric and the iron. Don't press too hard or you will flatten your work.

PINS

Use dressmaker or quilting pins to hold your projects together as needed when sewing or gluing. It's handy to have a pincushion nearby to place the pins when not in use.

SCISSORS

First, don't use your sewing scissors for anything other than sewing and embroidery for fear of lashing from the embroidery gods. They won't be as sharp or useful if you use them for cutting paper or other things. When cutting material, use fabric shears with sharp blades. For embroidery I prefer small, sharp scissors with pointed tips because they allow you to get really close to the thread and your fabric with precision and control. When snipping threads be careful not to snag your fabric, pull threads, or poke a hole (unless, of course, you want a hole).

Generally, embroidery is a very forgiving medium, but let's face it—we all make mistakes. If you don't like the color, size, or type of stitch you've sewn, you can easily remove it. But before you rip out your stitching try putting your project aside for a while. When you return, see if your work still reads as a mistake. If so, try to come up with a creative solution. If you've spent a significant amount of time on project, maybe there is a way to turn your mistake into a happy accident. Could you cover up the stitching? Could you add more of an offending color somewhere else for balance? Usually when something is repeated, it looks planned.

If all else fails and you decide to change or redo some of your stitching, you can snip the thread at the needle, pull the stitching out, rethread the needle, and then stitch again. But if your stitching is dense or complicated, it might be easier to use your embroidery scissors to snip the stitches in half and pull

the threads out with your fingers or tweezers. (Try cutting the stitches with regular scissors, and I'm sure you'll be a convert to embroidery scissors.) If you have "ghost" holes after removing your thread (especially if you used a large needle and delicate fabric) you can usually fix them by lightly steaming your work with an iron held just above the fabric, and then massage the threads back together.

STORAGE

I like to keep my embroidery supplies all together. You can use anything that suits your fancy and meets your needs. I found a great melamine picnic box that holds all my supplies. I also like to use plastic food containers to keep little doodads together.

THIMBLES

Thimbles—I have them, I love them as shapes, but I rarely use them. They are meant to protect the finger that pushes the needle through the fabric. At first, using thimbles can be awkward, but after a while, you will get used to having one on your finger.

When you sew a lot or sew through hard fabrics, thimbles prevent your finger from getting sore. Common sewing thimbles are made from either metal or leather. Leather thimbles (usually used by quilters) need to be replaced more often but are more comfortable to wear.

> **TIP** If you have to grasp your needle tightly to pull it through the fabric, your fingers will become sore. To reduce the finger strain, you can use a deflated balloon as grip to keep the needle from slipping out of your hands.

TRANSFER METHODS 101

You have your fabric (or other surface), and you have selected your thread, so you are all set to go! Oh wait, you need some art to embroider. And you need to get the design onto your fabric so you have guidelines to follow while you stitch. Here are the methods that my contributors and I used for the projects presented.

TRACING PAPER AND PEN OR PENCIL

Tracing an image to generate a simple line drawing, which you can then turn into a template, is an easy method for creating a design. The great thing about this method is you can work at any scale and adjust the size later. Use this technique if you want to create your own artwork, don't want to draw freehand on your fabric, want to alter a pattern or piece of art by removing or adding some elements, compile two things into one design, or do an embroidered piece based on a photo.

I like to make photocopies of my tracings and keep my originals in a folder in case I want to use them again. I also find tracing paper too flimsy to use on its own. Sometimes I cut up the copies and paste them together into a whole new design.

1. Secure the photo, clip art, or drawing you want to trace onto your work surface with a couple pieces of tape. Place the tracing paper over your image and tape it if you don't want it to move.

2. Trace the desired outlines. If you are tracing a photo, try to simplify the image. You can't embroider every detail, so pick the details and elements that you find most interesting; simplify, simplify, simplify. If you are working from a drawing or compiling two drawings or elements, choose what you want to use, and ignore the rest.

 Every now and then, slip a sheet of plain paper underneath the tracing paper to see how your line drawing is progressing. Does one area need more or less definition? Adjust as needed. You can always correct the image with white out when you are photocopying.

3. When you are happy with your tracing, think about scale. Do you need your template to be larger or smaller? Do you need one or ten copies of your art, or do you want to photocopy your template onto stiffer paper so it can withstand more use? Use a photocopier or scan your image and then print it to turn your drawing into the perfect template.

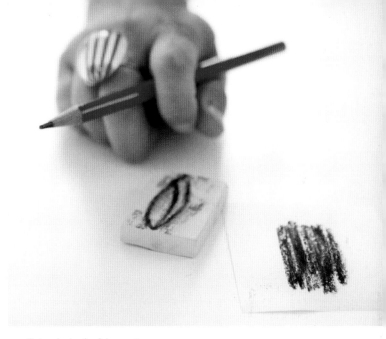

4. Place the new design underneath your fabric and trace the image to create guidelines for embroidery. You can also use your photocopy for the "Iron-on Transfer Pen" method.

RUBBING WITH TRACING PAPER AND PENCIL/CHARCOAL

This is a quick and easy way to transfer a template to a softer surface such as a printing block or linoleum block. It also works well on paper but isn't the best method for fabric.

1. Trace your design onto a clean piece of tracing paper.

2. On the back side of the tracing paper, use a soft #2 pencil or charcoal to cover the design (see A). You don't have to cover all the negative spaces, but be sure that lines of your design are covered.

3. Place your tracing paper with the design face up and pencil or charcoal side down onto your surface. Retrace the design lines to transfer the design to your surface (see B).

A. *Color the back of the tracing.*

B. *Retrace the design onto the block.*

TRACING WITH WATER-SOLUBLE PEN

This is my favorite method to transfer designs because it's easy and quick. The water-soluble pens available have vastly improved in the last few years. They come in pink, purple, and blue, and have a variety of tip sizes. The different colors help you to see your design on various fabrics, and the marks don't fade or disappear while you work. You can also use these pens to freehand draw a design onto fabric.

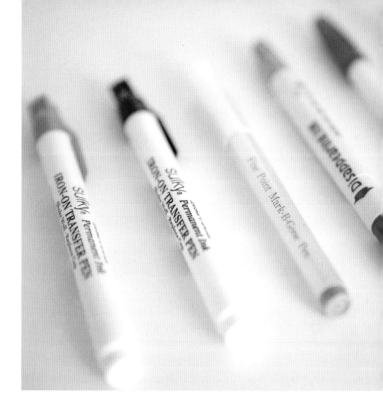

1. Place your template onto a light table and secure with tape it to keep it from moving. If you don't have a light table, don't despair. You can use a window; tape everything in position because you'll be working on a vertical surface. If you are using a light-colored fabric, you might be able to see through it without an additional light source, and can skip this step.

2. Position the fabric where you want your embroidery over the template. If you are worried about movement, tape the fabric down as well.

3. Use a water-soluble pen to trace the template onto your fabric.

4. When your embroidery is complete, do not press until you have removed the marks. Use a damp cloth to wipe away your markings. If you are having trouble getting to all the marks, use a spray bottle of clean water and spray your design until it's quite wet; the pen marks will dissolve away. Let your fabric dry completely. If any marks remain, rewet the areas until the marks are gone. If your piece is washable, one cycle in the washing machine will erase any trace. Avoid nonchlorine bleach, as it can turn the marks brown and make them difficult to remove.

WAX-FREE TRANSFER PAPER

This method works well when you can't see through your fabric to trace the artwork. I prefer wax-free transfer paper. Chalk paper works in the same manner, but it can be a bit messy. If you already have chalk paper, or that is all you can find, the directions remain the same.

1. Iron your fabric to remove any wrinkles. If your fabric will tolerate spray starch (and you have some handy), use a bit to stiffen the fabric—it's much easier to transfer if you have very smooth fabric.

2. Lay the fabric on a flat, hard, and smooth surface. Position the transfer paper facedown (color side down) on your fabric. Then place your art or template over the transfer paper. To be sure nothing moves, pin the two layers of paper to your fabric.

3. With a ball-point pen and some pressure, follow the template lines to transfer the pattern to the fabric. I recommend using a pen color that is different from your design so you can see where you have already traced.

4. Unpin a corner and check to make sure the design is transferring to the fabric. Repin the papers to the fabric and continue tracing the design.

> **TIP** Don't handle or touch the transferred art too much because the markings will begin to rub off. The transfer markings erase easily and will also come out with laundering.

PHOTOCOPY TRANSFER

This method produces a handmade, antiquated appearance. It looks great on paper and also works on fabric. When transferring to fabric, choose light colored cotton or linen that has a fine, smooth finish.

Because photocopies are black, your transfer will be black or gray. You can also transfer with color copies, but the resulting image may be muddy. The transferred image will be mirrored, so be conscious which direction you want your end result to face, especially if the image includes type. Text must be reversed when you copy it so that it will appear correctly when transferred.

You'll need a clear chartpak blender marker, or use xylol—available at your hardware store.

1. Work in a well-ventilated area—the fumes are not good to breathe!

2. Scale your artwork and create photocopies. You must use a photocopy or laser printout for this to work—carbon needs to be in the copied image (I repeat—no ink-jet printouts!).

3. Place the copy facedown on the surface where you want the transfer. Use your marker or a cloth dipped in xylol to saturate the photocopy concentrating on the image areas. Be careful not to oversaturate the paper, you don't want it to disintegrate during the next step.

4. Hold the photocopy firmly in place and use the cap of your marker or a spoon to rub the surface. Don't be afraid to rub fairly hard. I like to use a circular motion followed by back and forth strokes to completely transfer the image.

5. Check to see how the transfer is going and reapply pressure and/or more marker or xylol as needed.

IRON-ON TRANSFER PEN

When I first discovered these pens, I jumped for joy. These are so cool because they are permanent—once you iron them onto your surface, they will survive washing and dry cleaning, and they don't bleed. They come in eight colors: black, red, blue, orange, brown, yellow, purple, and green. The pens will also work with wood. They perform best on a light- to medium-colored surface. You can press the transfer again to for a second image, but it will be lighter than the first.

1. Place your template facedown on your work surface. If you have trouble seeing the design from the back, use a light box or window to help.

2. Shake, shake, shake your pen. Test the pen on a scrap of paper to make sure the ink is flowing. Make a few practice strokes so that you understand how thick and thin you can draw lines. Trace the lines of your template.

3. Turn your template face up and place it over your fabric or paper (or wood) you want to transfer the design to. If you are worried about moving the paper, pin the template in areas outside the art or design.

4. Set your iron on the hottest setting and turn the steam off. Press the iron evenly over the paper surface. Your photocopy or computer printout may blur from the heat, but it won't affect the transfer.

5. Do not lift up the paper and peek to see how the transfer is going or you might move the template and end up with a double transfer or some ghosting; just press evenly from one side to the other. I usually go over the design twice.

IRON-ON TRANSFERS

This is a great way to add embroidery over a photo, color pattern, or text. This method works best on light-colored cotton/polyester, 100 percent polyester fabric, or 100 percent cotton. You also need a computer, photo-imaging software, inkjet printer, iron-on transfer paper, and an iron.

1. Use a photo, clip art, or your own design scanned into your computer. You must "mirror" your art, because the final printed image will be a reverse of the original; use photo-imaging software. Print the picture onto regular paper as a test and then hold the image up to a mirror (or look through the back while holding it up to light) to see if everything appears correctly. If everything is okay, print the image onto the iron-on transfer paper following the manufacturer's instructions. Cut out your print, leaving a ¼" (6 mm) border around the image.

2. Empty the water reservoir of your iron, preheat to the cotton setting, and turn off the steam. Also cover a hard, smooth surface (such as plywood) with a press cloth or old pillowcase.

3. Position the fabric you're transferring to on the hard surface and then place the transfer paper facedown over the fabric. Press hard (use both hands) with a hot iron for one to three minutes, slowly moving the iron in circles over the whole image. If you iron too long, the transfer can melt into the fabric. Too little ironing may cause the image to peel off or crack—you may want to test on some scraps to get a feel for the process.

4. Let the transfer cool completely, and then starting at one edge, peel off the backing.

> **TIP** Be sure to read the instructions for the iron-on transfer paper and select the type compatible with your printer. A laser printer, or any printer that heats the paper, may be damaged if you use the wrong paper because the transfer-paper coating could melt.

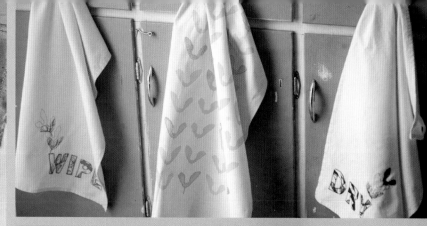
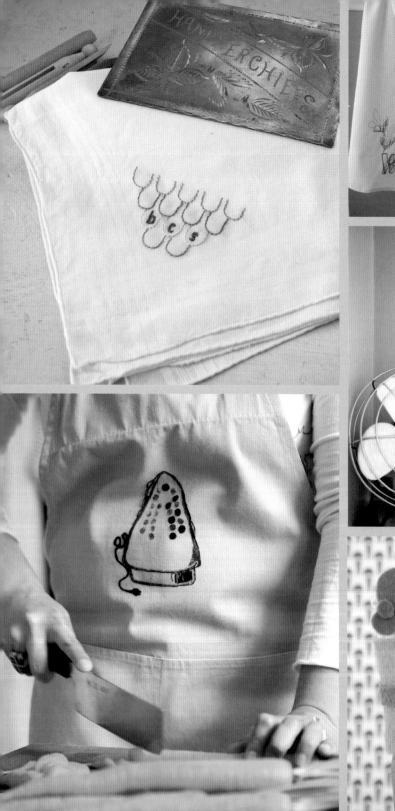
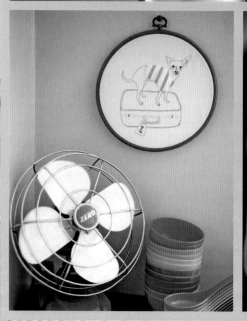

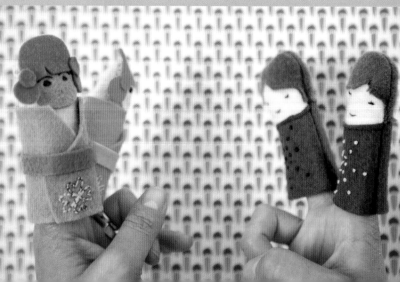

CHAPTER TWO

MAKE STUFF

I don't know about you, but I rarely make projects I see in craft books exactly the way authors suggest them. Mostly I use my craft books (and I have a huge collection of them) as inspiration or as teaching tools. I like to flip through them and look at the pretty pictures or take a technique and apply it to something else I'm making. When I was dreaming about projects for this book, I thought: Wouldn't it be fun if I came up with an idea and then handed it over to an artist or crafting friend and had them do a version? I envisioned our wildly different interpretations of the same project working side by side in harmony, and hopefully empowering you to take these general ideas and create your own versions.

If you have never embroidered before, don't fret! Included are simple projects that will get you started. And if you are an embroidering pro, I hope you'll find some templates and ideas that are fresh and inspiring to you.

I'm a huge fan of mixing media and techniques. You can stitch on most fabrics and with almost any type of thread. Thread is such a beautiful way to add texture, color, and dimensionality to art. Don't be afraid to make up your own version of a stitch, especially if you feel you can't replicate something you see. Also, don't worry about your stitches being perfectly even—often imperfections in embroidery are the most interesting part.

You could easily swap out almost any template and blank in this book to come up with an entirely new project. You could make a pillowcase embroidered with the word "sleep," add hexagons or a felt robot to a pillow, or put Wilfredo on a T-shirt —the combinations are endless, you just have to get started!

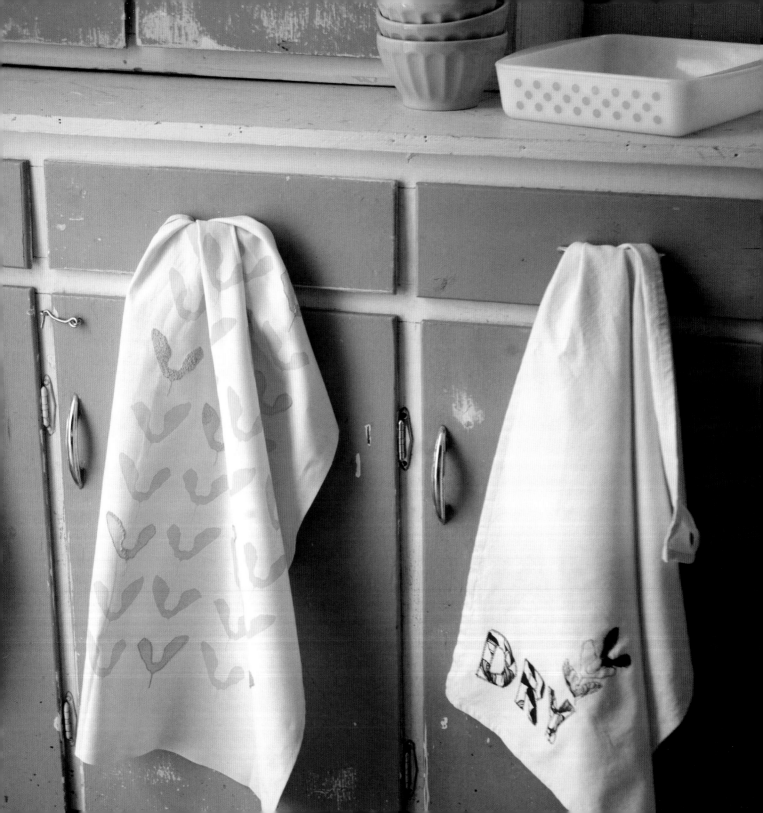

TEA TOWELS

PART 1: WIPE AND DRY TOWELS
WITH A SYCAMORE POD PATTERN

MATERIALS

- 2 (or more) printed tea towels or print fabric
- 2 blank tea towels (see "Resources")
- wipe and dry template on page 128 (or create templates of your own using your favorite font and words)
- sycamore pod template on page 128
- pencil or pen
- iron-on fusible tape
- sewing machine with free-motion presser foot

TRANSFER METHOD

- tracing with water-soluble pen (see page 22)

THREAD/STITCHES

- all-purpose sewing thread, coordinating or contrasting colors for wipe and dry
- twisted silk embroidery floss for sycamore pods
- free-motion and zigzag stitching on machine
- backstitch (see page 136)
- outline stitch (see page 138)
- seed stitch with a single strand of the twisted silk

There are so many gorgeously designed printed tea towels these days. Sometimes I think it's nice to add a handmade touch to something already in existence. This is also a great project to make use of scraps of fabric you have lying around—you don't need much to spell out words or phrases in appliqué.

You could do this project with almost any printed fabric you find inspiring. The trick is figuring out where and what to stitch, and selecting a printed fabric that would work well with the lettering. A smaller print is often best because it reproduces well within the letters.

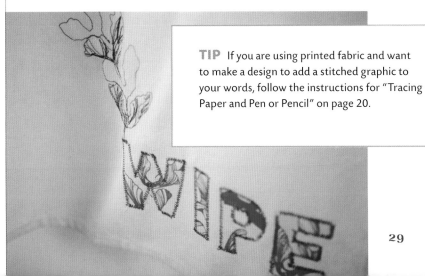

TIP If you are using printed fabric and want to make a design to add a stitched graphic to your words, follow the instructions for "Tracing Paper and Pen or Pencil" on page 20.

29

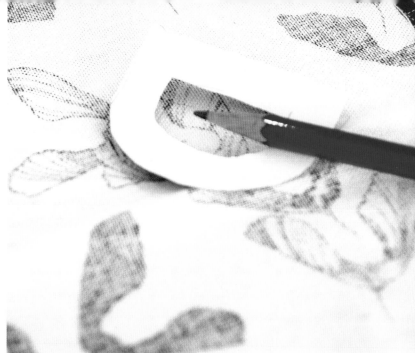

A. *Place template over the design element.*

1. Prepare your templates by cutting out each letter.

2. Place the templates over the printed tea towels or fabric, making sure that an interesting design will fill each letter shape (see A). Trace around the templates with your pencil or pen. In the featured project, I used one color for each word—you could easily mix it up or use the same color for both words.

3. Carefully cut out each letter from the fabric. Try and cut just inside the traced line, but don't worry if a little bit shows because you will be stitching over the edges.

4. Position the letters on your blank towels. I chose to put mine in the corner because they will show when the towels are hung up.

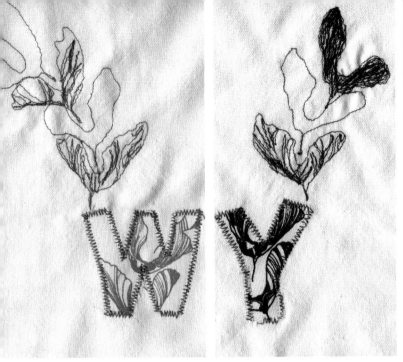

B. *Sycamore pod accents added words.*

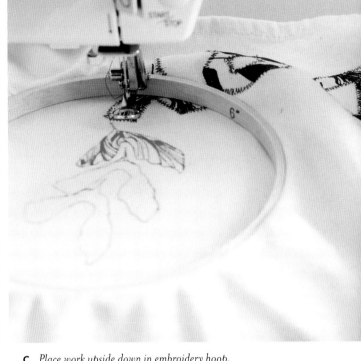

C. *Place work upside down in embroidery hoop.*

5. Cut pieces of iron-on fusible tape to fit on the back side of the letters.

6. Using a hot iron, fuse the letters to the towel following the manufacturer's instructions. (Using fusible tape usually requires you to turn off the iron's steam setting.)

7. Copy the sycamore pod template and place it as desired; trace using wax-free transfer paper. I used the three-part sycamore pod drawing for the word *dry* because it has three letters, and the four-part sycamore pod drawing for the word *wipe* because it has four letters (see B).

8. Use a coordinating or contrasting color thread and zigzag stitch around the edges of each letter on both towels.

9. Refer to your sewing machine manual and set up for free-motion quilting, embroidery, or darning stitch. Usually this entails lowering the feed dogs and switching the presser foot. Some manuals suggest you place your work upside down in an embroidery hoop to keep the fabric taut (see C).

10. Using a straight stitch, follow the sycamore drawings on both towels. You will be able to move the work back and forth at will. If you've never done this before, you might want to practice on a piece of scrap fabric first.

11. Trim all your threads and voilà! You are ready to wipe and dry.

PART 2: HAND-EMBROIDERED GOLDEN SYCAMORE PODS ON A PRINTED TEA TOWEL

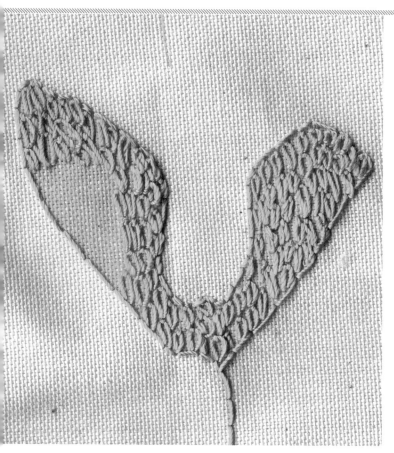

A. *Use detached chain stitches to fill areas.*

1. Look at the tea towel and select the design areas you want to embroider. I used a tea towel with syca-more pods printed in rows. I chose one motif from each row, outline stitched around the shape, and then filled them in to various degrees. You should work toward creating a balanced design when the stitching is finished. Consider how combining several different embroidery styles and alternating the method and amount of filling in the motifs will work as a whole.

2. Place the tea towel in an embroidery hoop and start stitching. For shapes that are just outlines, use an outline stitch. For the completely filled (or semi-filled) shapes, use a detached chain stitch and outline with a backstitch (see A).

3. Take a step back periodically to get an overview of the whole towel. Other pattern ideas to try would be to fill in designs to create a row, fill in four motifs to make a square, or start at one corner and fill motifs diagonally back and forth.

4. I almost used one of these two towels instead (see B). It would be fun to embroider over one flower or parts of the petals; it's easy to find something already printed as inspiration.

B. *Think about accenting different areas with embroidery.*

ARTIST VERSION: EAT, DRINK, AND CLEAN HAND LETTERING

with lettering by Kate Bingaman Burt

MATERIALS

- three blank tea towels (see "Resources")
- Eat, Drink, and Clean templates on page 128

TRANSFER METHOD

- iron-on transfer pen (see page 24)

THREAD/STITCHES

- cotton embroidery floss in various color combinations
- Eat: diagonal straight stitches (double strand) (see page 139)
- Drink: couched straight stitches (triple strand) (see page 139)
- Clean: modified honeycomb stitch (double strand) (see page 137)

I'm sure you've seen tea towels that show the days of the week. I thought it would be fun to update this concept and invited artist Kate Bingaman Burt do some hand lettering for tea towels that, in her words, "bark orders" at you. In stitching them I wanted to try out different techniques and colorways. I wanted them to work as a set or individually. You could coordinate the stitching and colors on all three towels, or just do your favorite word, or put all three words on one towel.

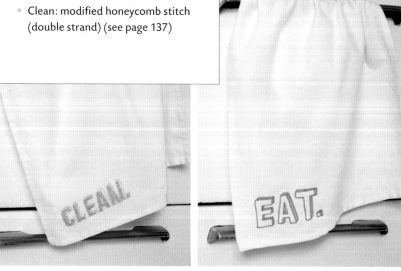

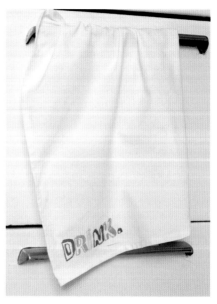

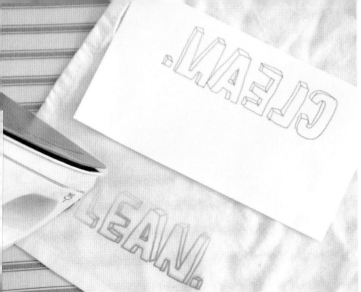

A. *Transfer the design.*

B. *Photocopy and color the template to determine your palette.*

1. Determine the word placement on the towels. I chose to position mine in the lower left corner, but there are many other options. Transfer the design (see A).

2. To personalize these towels or have them match a particular kitchen, photocopy the template, and try out different palettes using colored pencils (see B).

3. Embroider the words (see C), and then do what they say!

> **TIP** If you want to use a hoop to embroider these designs, be aware that you need a hoop larger than the image so there is enough room to work the stitching, or be prepared to move your hoop around the work as needed. Sometimes I find it's easier to tackle one letter at a time.

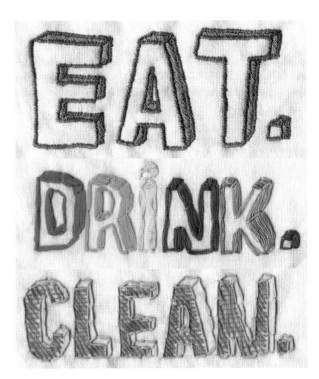

C. *Stitch over areas to accent the image.*

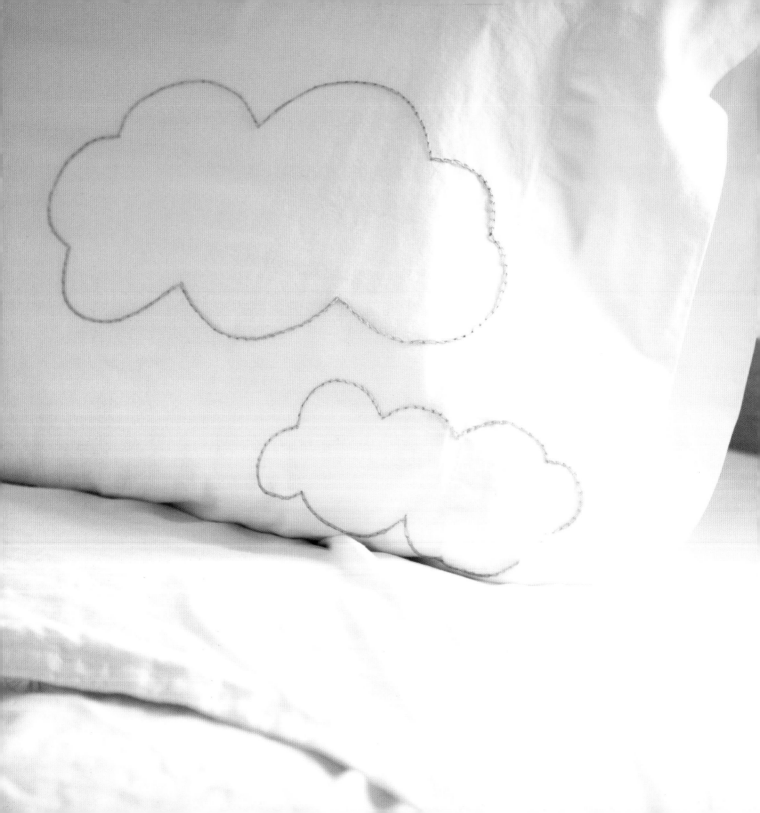

PILLOWCASES

PART 1: SLEEPING ON CLOUDS

MATERIALS
- cloud template on page 129

TRANSFER METHOD
- tracing with water-soluble pen (see page 22)

THREAD/STITCH
- cotton embroidery floss, double strand
- chain stitch (see page 137)

Imagine sleeping on a cloud. I added my quirky and cute cloud illustrations to pillowcases in colors that coordinate with the pre-existing bedding in my home. This type of project is a quick and easy way to spruce up your bed without spending a fortune or a lot of time. Did I mention these would make a sweet gift too?

1. Position the cloud template on your pillowcase and transfer the design. The samples feature a white pillowcase embroidered with blue thread for a twin bed and green pillowcases with white thread for a queen-size bed. Place the clouds wherever you want, but if you are going to sleep on the case, as opposed to using it decoratively, you might want to place the clouds toward an edge rather than where your cheek might lie.

2. Place the design in your embroidery hoop and chain stitch following the lines.

3. Remove the hoop, insert a pillow, fluff, and throw them on your bed!

ARTIST VERSION: ARROW PILLOWCASE

by Martha McQuade

MATERIALS

- pillowcase
- arrow template on page 130

TRANSFER METHOD

- wax-free transfer paper (see page 23)

THREAD/STITCHES

- all-purpose light gray or silver sewing thread
- cotton embroidery floss, full strand in dark gray, orange, pink, green—or colors of your choice
- backstitch (see page 136)
- machine straight stitch

While researching embroidery stitches online, Martha was immediately attracted to the geometric arrowhead stitch. Sharon Boggon, in her online stitch dictionary (http://inaminuteago.com/stitchindex.html), said that the arrowhead stitch "is simple and quick, making it an ideal embroidery stitch for those new to hand sewing," which she thought was perfect for her since she had never embroidered before.

She wanted to focus on the hem of the pillowcase and thought the arrow shapes would work well within that long rectangular shape. She divided the rectangle up evenly to make it easier to work with and then started drawing. As the sketch evolved, she liked the visual texture that was developing by concentrating the lines of the arrows closer or farther apart (see A). After a while, she started to see a continuous line that linked all the sections together. This became the heavier dark-gray stitch in the final piece. What she had drawn was too large to use the arrowhead stitch, but she liked her sketch and didn't want to abandon it. She made the decision to just use a straight stitch on her machine to execute the pattern. For the hand stitching, she tried using an embroidery hoop but found it easier and quicker to stitch without one.

Martha, a complete newbie to embroidery, decided to use a stitch as a launching point for her design but that she didn't feel tethered to the stitch once it seemed it wouldn't work. Also, her story may encourage you to ditch the embroidery hoop if it's making your life more difficult.

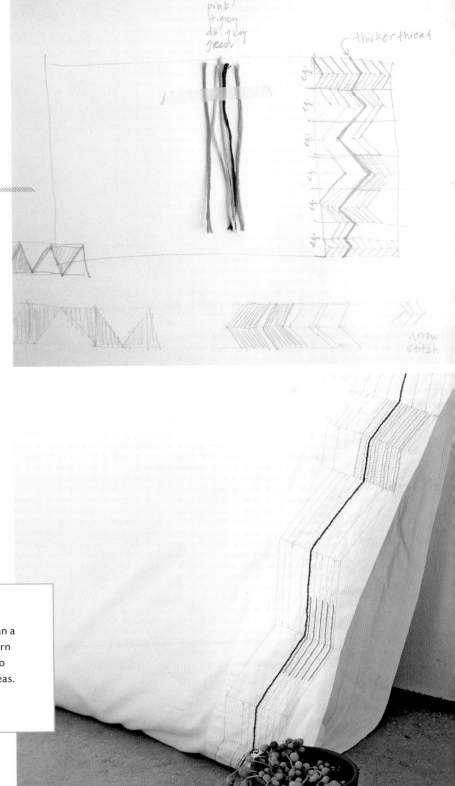

A. *Martha's sketches as she planned her design.*

1. Using the template, transfer the arrow pattern to the pillowcase hem.

2. Use a sewing machine to straight stitch the light gray or silver lines (or use a color of your choice).

3. Using a full strand of dark gray embroidery floss, backstitch the long, thicker zigzag line that stretches from top to bottom.

4. Use full strands of orange, pink, and green floss (or colors of your choice) and fill the areas with rows of backstitching, following the template lines.

5. Insert pillow and fluff.

TIP For more diversity in texture, experiment with different thread thicknesses. Use more than a full strand of floss, thicker crochet thread, or yarn for the dark gray top-to-bottom zigzag. Use two or three strands of floss for the accent-color areas.

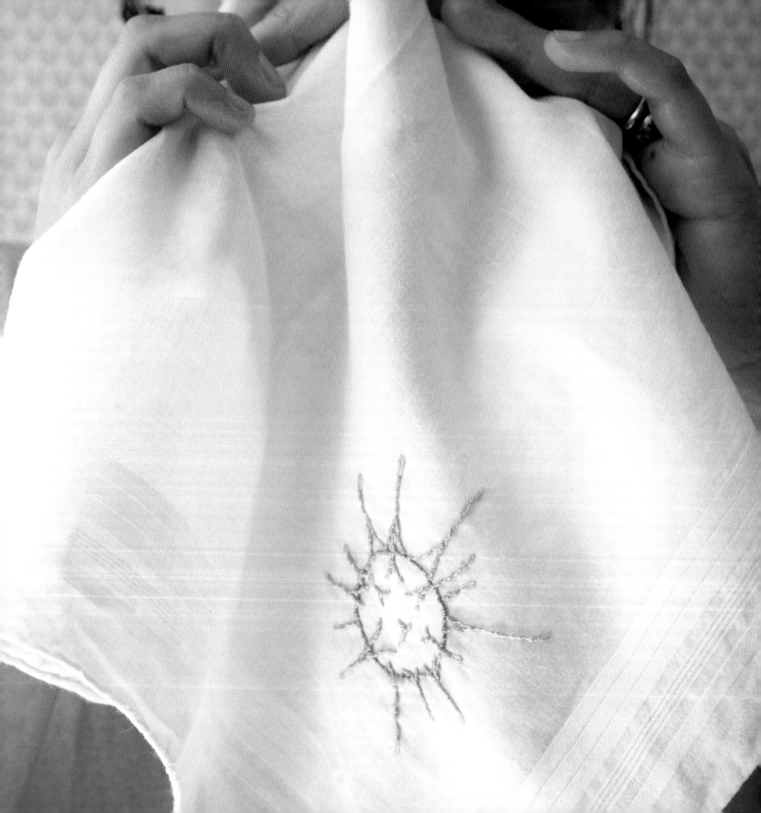

HANDKERCHIEFS

PART 1: FIGHT THAT COLD!

MATERIALS
- blank handkerchief (see "Resources")
- cold virus template on page 129

TRANSFER METHOD
- tracing with water-soluble pen (see page 22)

THREAD/STITCHES
- cotton embroidery floss, double strand in two colors
- backstitch (see page 136)
- detached chain stitch (see page 137)
- whipstitch (see page 139)

Hankies are incredibly versatile and handy, not to mention better for the environment than tissues. You can dry your hands, dab a coffee drizzle from the corner of your mouth, or blow your nose. Why not personalize one with an updated and contemporary monogram?

Ever since my daughter was born, I'm always in need of a hanky to wipe sticky hands or a nose. I've also been sick more frequently, so I thought it would be funny to put a drawing of a cold virus on a handkerchief, especially because the virus itself is rather pretty (and more my style than a frilly rose).

1. Figure out where you want the cold virus to live on your hanky. Trace the design with a water-soluble pen.

2. With one color of floss, backstitch and whipstitch the circle of the virus (see A).

3. Use the second color of floss to backstitch and whipstitch all the radiating lines of the virus and add a detached chain stitch to the end of each line.

4. Blow your nose!

A. *Embroider the center circle.*

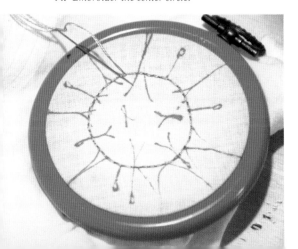

ARTIST VERSION: EMBROIDERED SCALES AND HE LOVES ME HANKIES

by Blair C. Stocker

FONTS

- Embroidered Scales:
 Helvetica, 40 pt
- He Loves Me:
 American Typewriter, 28 pt

MATERIALS

- blank hankies (see "Resources")
- Embroidered Scales:
 scale template on page 130
- He Loves Me: a small flower or leaf
 cut from fabric to appliqué
- hand-sewing needle
- pins
- computer and printer

TRANSFER METHOD

- tracing with water-soluble pen
 (see page 22)

THREAD/STITCHES

- Embroidered Scales: five colors
 of cotton embroidery floss, triple
 strand
- He Loves Me: two colors embroi-
 dery floss (one color to coordinate
 with appliquéd fabric)
- backstitch or split stitch (see pages
 136 and 138)
- running stitch (see page 138)

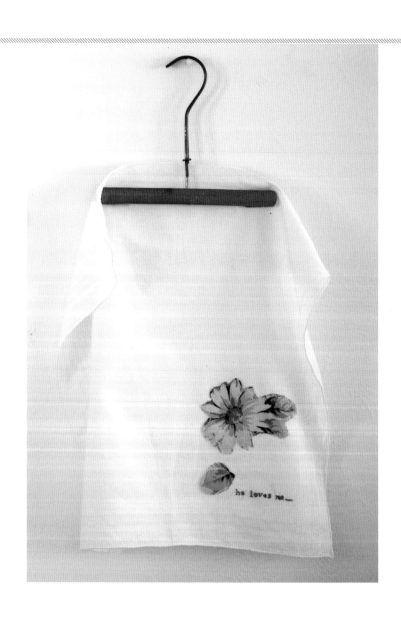

he loves me...

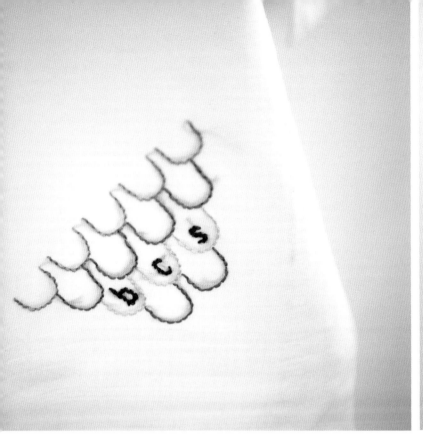

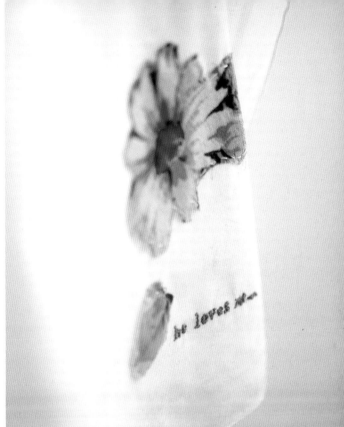

1. Type your initials (you may need to adjust the size to fit in the scale pattern) or the phrase "He [or She] Loves Me" on the computer. Print out the words or initials. You can use the fonts Blair used or find your own.

2. Place your design or phrase and trace onto your hanky with the water-soluble pen.

3. Embroider the lines and letters.

4. For "He Loves Me," cut out a pretty flower or leaves from fabric, pin in place on the hanky close to the embroidered phrase, and then sew a running stitch around the outside edge. (Raw edges are okay—they may fray a tiny bit at first, but no more. If you are worried, apply a product to stop fraying after cutting out the image.)

ARTIST VERSION: UPDATED MONOGRAMS

by Blair C. Stocker

FONT

- American Typewriter, 72 pts

MATERIALS

- blank handkerchief (see "Resources")
- six small scraps of cotton quilting fabric (Blair used men's shirting fabric)
- handkerchief hexagon template on page 129
- pins or glue stick
- hand-sewing needle
- white paper computer and printer

TRANSFER METHOD

- tracing with water-soluble pen (see page 22)

THREAD/STITCH

- coordinating all-purpose sewing thread
- cotton embroidery floss, one color, three strands
- split stitch (see page 138)

I asked Blair to create hankies with a "new, yet traditional" feel—a different spin on the usual flowers and initials. Looking at examples from her husband's grandmother, Blair noticed the initials and decoration were gorgeous filigree. For these updated versions, she decided to use straight, generic fonts as a contrast to those. The fonts she used are common and widely available on most computers. She (and I) loved the idea that a hanky is like a little tiny bit of art in your pocket.

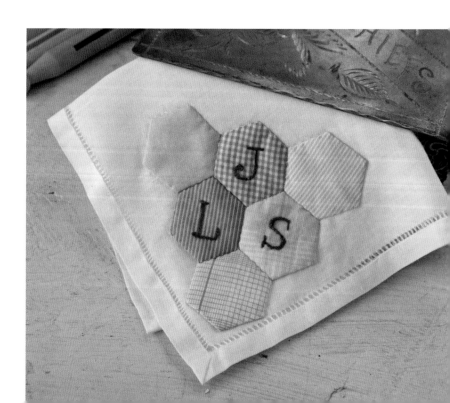

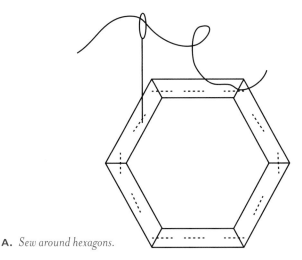

A. *Sew around hexagons.*

1. Copy the hexagon templates by hand, or scan the image and print it onto white paper (scrap paper is fine). Cut out as many hexagons as you plan to use (Blair used six). Press the cotton fabric scraps, and then position a paper hexagon on the wrong side of each scrap with at least a ¼" (6 mm) wide space beyond the hexagon; pin in place.

> **TIP** Instead of pinning the paper hexagons to the fabric, you can use a glue stick to adhere the paper in place.

> **TIP** Finger-press means that you use your hand instead of an iron. Place the hexagon on a flat surface and run your index fingernail (or thumbnail) over the seam until it lies flat.

2. Trim the fabric around the paper hexagons, leaving a ¼" (6 mm) seam allowance. Fold the seam allowance along the paper's edge and finger-press the fold. With a needle and thread, sew around the hexagon through the fabric and paper using small, running stitches (see A). Do this for each hexagon. After the edges are sewn, you can tear out the paper. Then sew the hexagons together as shown in the photo at left. Place two hexagons with right sides facing, and hand-sew them together with small stitches along the folded edges.

3. Type your initials with size 72-pt American Typewriter font. You can use any font, but keep in mind that you will be embroidering it on the small hexagons, so a simple font will yield the nicest results. Print out your initials.

4. Trace the initials onto the hexagons with the water-soluble pen.

5. Embroider the initials with a split stitch (see page 138).

6. Press the hexagons so they are very flat and neat. Position and sew the hexagon outer edges onto the hanky with a stitch. Use thread that matches the hanky so it looks neat on the back.

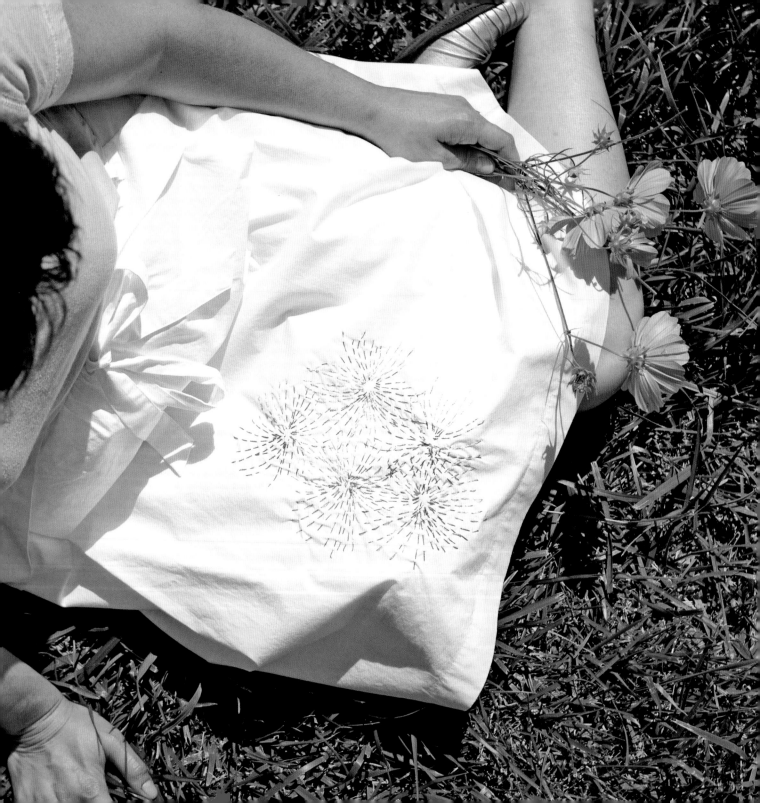

CONTEMPORARY SASHIKO

PART 1: FIREWORKS SKIRT

MATERIALS
- sashiko needle (substitute a doll needle or use the longest needle in your collection)
- skirt
- sashiko fireworks template on page 130

TRANSFER METHOD
- tracing with water-soluble pen (see page 22)

THREAD/STITCH
- metallic embroidery floss, double strand
- sashiko stitch (see page 138)

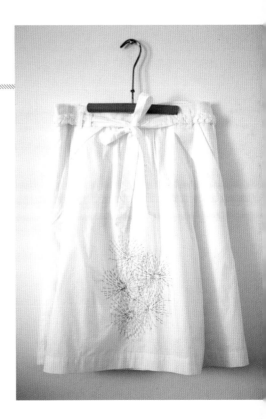

Perhaps it's my way of getting in touch with my heritage, but I seem to be continually drawn to traditional Japanese crafts and folk arts. I've always wanted to give sashiko a try (so many possible patterns and not enough time!). Sashiko, which means "little stabs" in English, is a traditional Japanese embroidery technique. Historically sashiko was used to repair/decorate clothing and often put on patches. It's a running stitch that uses a long needle to pull threads along a linear design. There are hundreds of traditional patterns with patterns often abstracted from natural forms like wisteria, the ocean, and so on.

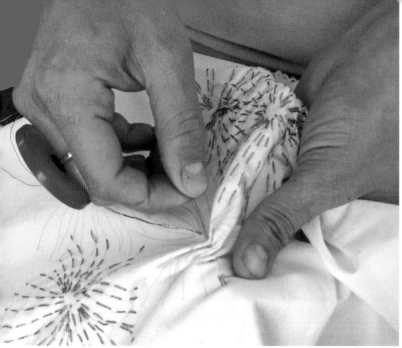 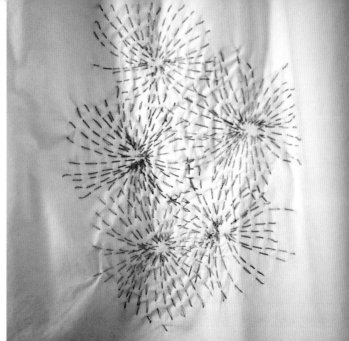

A. *Embroider the center circle.*

I thought it would be fun to use this technique to do something a bit more contemporary. It's nice to take something in your wardrobe that's rather plain and give it new life, so I decided to embellish the front of a skirt with a pattern loosely based on fireworks (I thought the fireworks were reminiscent of a chrysanthemum, which is common in Asian art). Traditional sashiko uses a dense cotton thread, but I wanted some sparkle, so I used metallic embroidery floss. The skirt I used had distinct panels and pleats, so I decided a center placement would work best. I could also envision this design repeated several times or placed off to one side. If a skirt isn't an option, consider embroidering your fireworks onto a shirt, pillow, or anything else that needs some sparkle.

1. Copy and print the template to a size that will work on your garment.

2. Trace the design onto the garment with the water-soluble pen and then embroider.

3. The sashiko technique bunches the fabric on the needle (see A) causing lots of wrinkles, so iron or steam the completed embroidery.

> **TIP** Metallic floss is quite slippery. It can be challenging to knot, plus it gets caught on itself and frays easily. I used a long single strand doubled over to avoid fraying and a quilter's knot (see page 137) at the beginning.

ARTIST VERSION: SIMPLE COASTERS

by Sally J. Shim

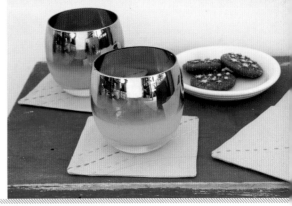

MATERIALS

- eight 5" (13 cm) squares of cotton fabric
- four 4½" (11.5 cm) squares of cotton batting
- ruler
- water-soluble pen

THREAD/STITCH

- pearl cotton, size 5 in two colors (traditional sashiko or embroidery floss would also work)
- sashiko stitch (see page 138)

When I approached Sally about working on a sashiko project for the book, she claimed she was excited, and a bit terrified, because she had never tried sashiko before. When I look at Sally's beautiful blog and paper projects, I'm always amazed at how everything she makes is impeccable, down to the smallest detail; these coasters are no exception. The design is very simple, and her use of neutrals is subtle but lovely. These are a great beginning sashiko project! I could see making matching placements or using them in a quilt.

A. *Diagonal, parallel lines*

1. On four of the cotton squares, use a ruler and water-soluble pen to draw a diagonal line from corner to corner.

2. Draw a parallel line ¾" (2 cm) away on both sides of the diagonal line.

3. Embroider the first diagonal line and then use a contrasting thread to stitch the two parallel lines (see A).

4. With right sides facing, place a plain square and a stitched square together.

Place a batting square on the back of the plain square and pin edges.

5. Using a ¼" (6 mm) seam allowance, stitch around the edges of the coaster leaving a 2½" (6 cm) opening on one side for turning.

6. Trim the corners close to the stitching and then turn right side out.

7. Press the coaster edges, folding in the opening seam allowances. Pin the opening and blindstitch closed. Repeat to make the remaining three coasters.

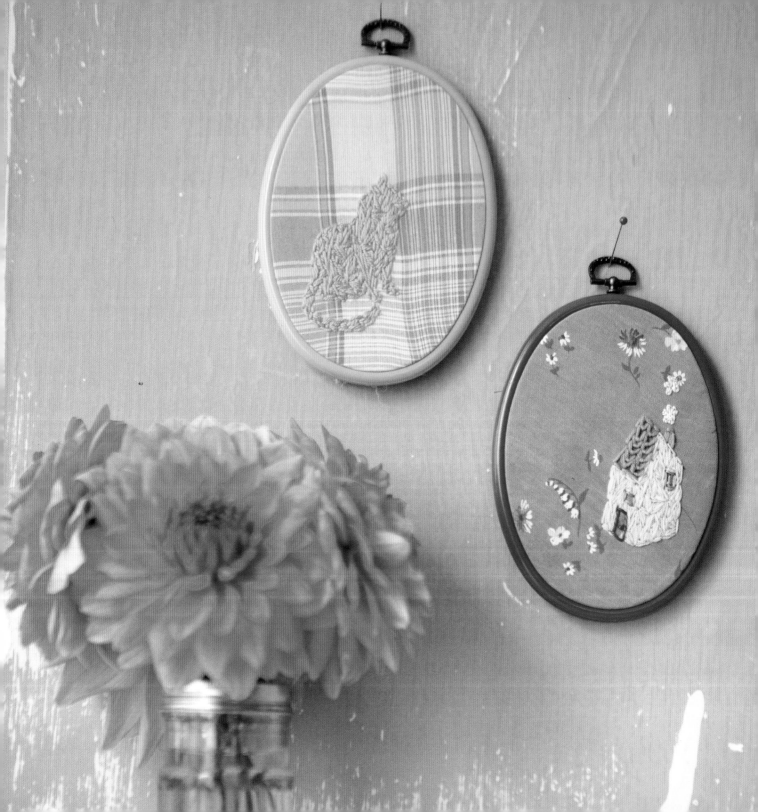

INSPIRED SILHOUETTES

PART 1: WILLY NILLY STITCHED CAT AND HOUSE

MATERIALS

- vintage fabric, enough to fit your hoop
- chenille needle
- cat and house template on page 130, or your own silhouette

TRANSFER METHOD

- iron-on transfer pen (see page 24)

THREAD/STITCH

- yarn in various colors (I used scraps of different weights and blends—the cat is in cotton, the house incorporated wool)
- backstitch (see page 136) to outline the silhouette
- cat: straight stitch (see page 139) in various lengths and directions until shape is filled
- house: same as above, plus backstitch (see page 136) around door and windows, French knot (see page 137) for doorknob, and open detached chain stitch (see page 137) for roofing

The silhouette was very popular in the eighteenth century and has gone in and out of fashion over the years. Usually, silhouettes are cut out of paper or painted, and they are typically filled in with a dark color. I thought it would be fun to revamp the silhouette by adding color, textures, or patterns via the stitching. To bring the color to another level, I decided to embroider on top of some vintage fabric scraps from my stash. Because most traditional silhouettes appear flat, I wanted to counter that by creating something really textured. I used my cat as a model and then decided I also wanted to do a house—my take on "home sweet home." I have a box of gorgeous vintage embroidery hoops in funky colors, so I used one of those as a frame. Susan Bates currently makes a line of plastic hoops, which you could substitute if you like this look (see "Resources").

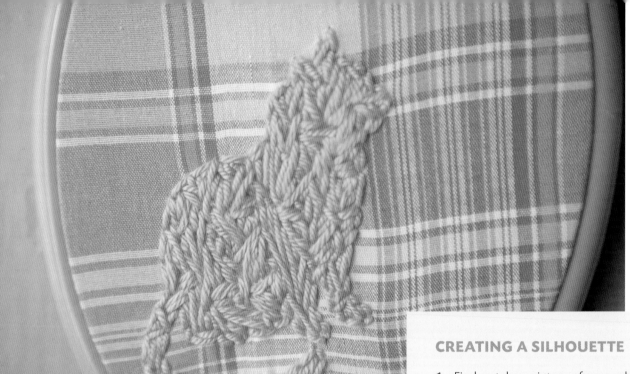

1. Scale the template to your desired size or use your own silhouette. Use the iron-on transfer method to place the image on your fabric. Consider the design placement; centered is more traditional, but I went for a lower quadrant placement.

2. Outline the shapes with a backstitch and then fill in with straight stitches; add details (eyes, nose, whiskers) as desired.

3. If you want to use your embroidery hoop as a frame, consider gluing it in the same manner used for "Wilfredo" on page 87.

CREATING A SILHOUETTE

1. Find or take a picture of your subject. Side views tend to provide the most interesting shapes for people and animals, but plants and many objects would look fine with a frontal view.

2. Copy or print the image, enlarging the photo to the desired size.

3. Outline the silhouette using tracing paper and pen or pencil.

4. Transfer the silhouette onto your fabric using wax-free transfer paper, tracing, or iron-on transfer pen.

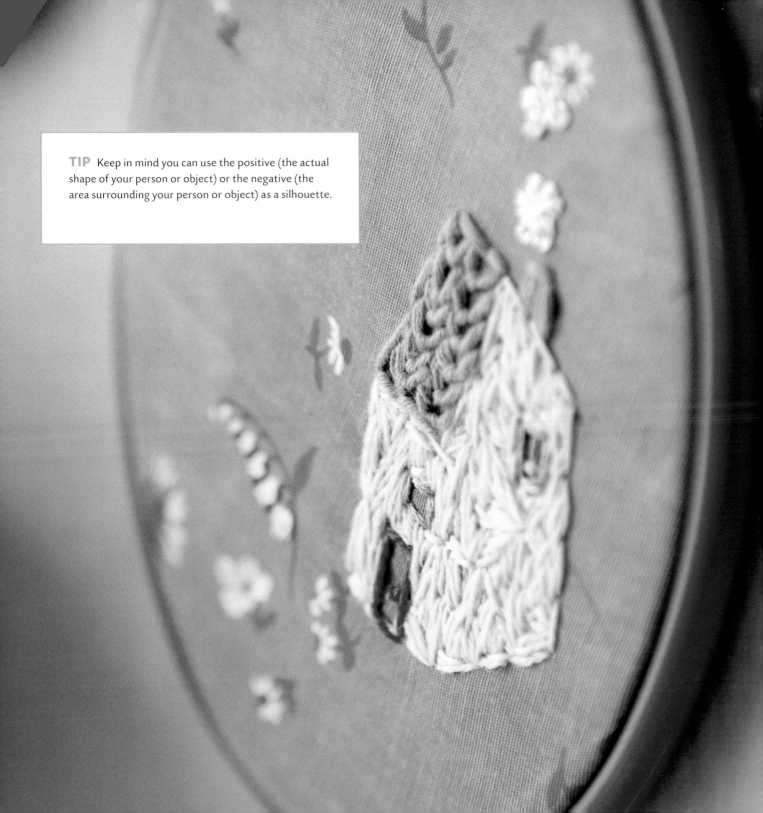

TIP Keep in mind you can use the positive (the actual shape of your person or object) or the negative (the area surrounding your person or object) as a silhouette.

ARTIST VERSION: FLORAL SILHOUETTE PILLOW
by Lisa Congdon

MATERIALS

- 9¼" × 11½" (23.5 x 29 cm) rectangle of linen fabric
- felt or another fabric: 5½" × 11½" (14 × 29 cm) for upper back panel, 6" × 11½" (15 × 29 cm) for lower back panel
- floral silhouette template on page 130
- sewing machine
- optional: button and buttonhole maker to close pillow (or leave as a flap or use ribbon to tie closed)

TRANSFER METHOD

- wax-free transfer paper (see page 23)

THREAD/STITCHES

- cotton embroidery floss: one to five colors, double and triple strands
- chain stitch (silhouette outline) (see page 137)
- running stitch (flowers, background) (see page 138)
- French knots (inside the flowers) (see page 137)

Lisa made this silhouette from a kindergarten picture of herself. I thought of her for this project because I've seen her make and use silhouettes in her artwork for years (she resurrected this one from a series of work done in 2006). I love how Lisa made the silhouette more contemporary by filling the shape with a freehand-stitched floral pattern. Freehand stitching can be challenging when you first begin, so feel free to use the template provided. But remember, you can freehand or draw your own pattern and add it to this or any silhouette. Frame or hang your silhouette as an art piece or turn it into something functional such as a pillow.

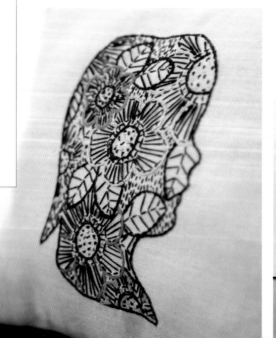

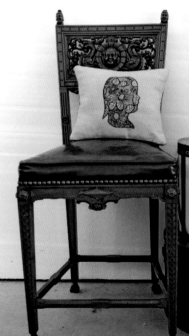

1. Scale the template to the size you want and transfer it to the center of the linen.

2. Insert the fabric into your hoop and use a chain stitch to outline (Lisa used black). Then think about how you want your pattern to work. Will all the flowers be the same color? Do you want the bigger flowers one color and the smaller flowers another? Do you want to rotate colors from top to bottom (red, yellow, blue, trying to keep like colors from being next to one another)? Once you've decided, use a running stitch to outline and fill in the flowers. Then decide which thread to use for the French knots inside the flowers.

3. If you want to use a button to close the pillow, make a buttonhole centered along one 11½" (29 cm) edge of the upper back panel, about ½" (1 cm) from the edge (refer to machine's manual for buttonhole instructions). Use embroidery scissors to cut open the hole.

4. With right sides facing, pin the upper back felt panel to the embroidered linen, aligning the long edge without the buttonhole with the linen edge. Pin a long edge of the lower back panel to the opposite linen edge. The back panels should overlap at least 1" (2.5 cm). Sew around the perimeter with a ¼" (6 mm) seam, trim the corners, and turn right side out.

A. *Add buttonhole and button to close pillow.*

5. Position the button on the lower panel underneath the buttonhole and stitch in place (see A).

6. Insert a pillow form, button, and fluff. (You can buy an insert or have one made to a specific size. See "Resources.")

MAKE A CUSTOM PILLOW FORM

I made a pillow form from two 9¾" × 12" (25 × 30.5 cm) rectangles of muslin, which are ½" (1 cm) larger in size than the linen piece. Place the rectangles together and sew around the perimeter with a ¼" (6 mm) seam; leave a 1½" (4 cm) opening on one side for turning. Turn right side out, stuff with fiberfill, and stitch the opening closed with a blindstitch. Since the form is slightly bigger than the cover, it will fill the cover more completely.

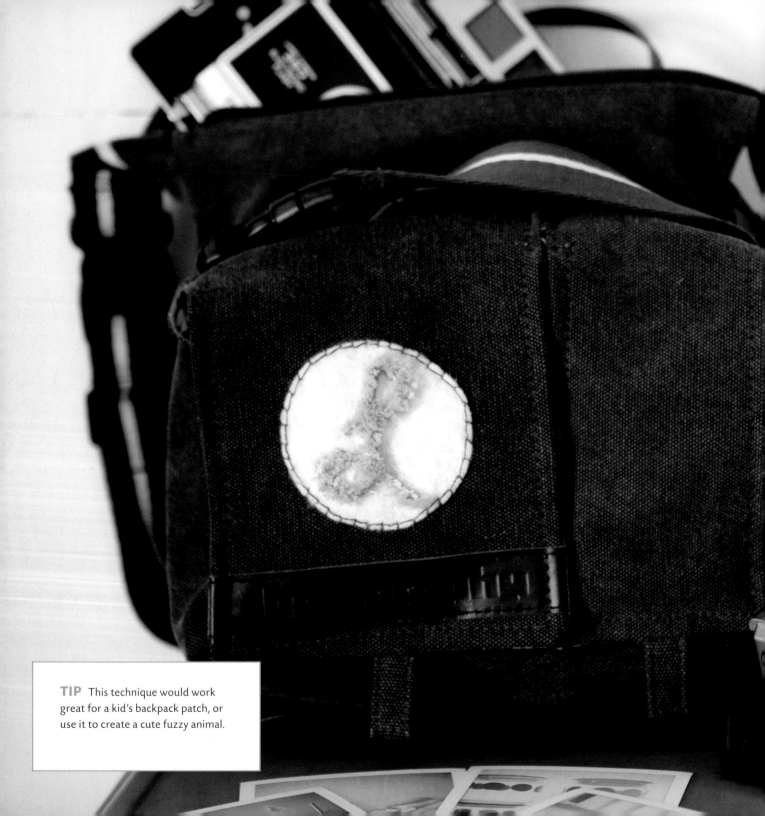

TIP This technique would work great for a kid's backpack patch, or use it to create a cute fuzzy animal.

MONOGRAM PATCHES

PART 1: SHAGGY RED CROSS AND INITIAL

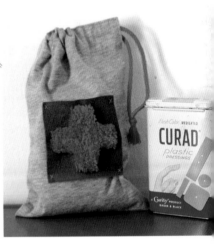

MATERIALS

- two 3" (7.5 cm) pieces of felt, one circle and one square (adjust the size as needed)
- cross template on page 131 drawing of an initial, or shape
- fine-tip permanent marker or ball-point pen
- tape or lint roller

TRANSFER METHOD

- draw around paper template with permanent marker

THREAD/STITCHES

- cotton embroidery floss, full strand
- blanket or cross-stitch (see pages 136 and 137) to tack down the patch
- turkey stitch (see page 139)

Not only can you update and modernize monograms, you can make them downright fun and almost silly! And you can decorate almost anything. I like to use felt for the base of my patches—it doesn't fray, is pretty durable, and comes in many colors.

I love the idea of personalizing useful things that surround you. I also have a secret love of shag carpet (albeit in small doses) because of how it feels. Part of the allure of embroidered objects is how they feel. Here's a way to make your embroidery three-dimensional and have texture too.

The turkey stitch was used here to create a shag effect on two patches. I wanted to decorate a little bag that I use as a first-aid kit, so a red cross was in order. I also wanted to monogram my camera bag, and feeling in a retro-modern sort of mood, I decided to use a cursive "L" initial—I picked a font that has some character, but isn't too frilly.

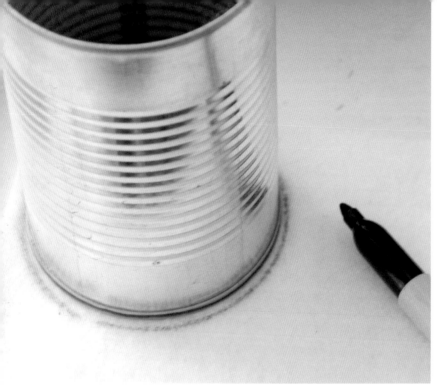

A. *Trace around a can, or other object for the patch base.*

B. *Trace the letter onto the felt.*

1. For a circle patch, use the permanent marker to trace around the bottom of a can onto the felt (see A). A ball-point pen or permanent marker makes the clearest marks on felt. Cut out your felt base just inside the lines so they don't show. You can make either of these patches larger, but I wouldn't recommend smaller for this technique. Find the center of your felt patch by folding it in half vertically and then horizontally; use your maker to make a dot in the center.

2. Print or draw a letter or shape the size you want to use; cut it out to use as a template. If you are using an initial, make sure you also cut out any internal shapes in the letters (triangles for As, circles and loops for Ls, Bs, etc.).

3. Center and pin your template on the felt; trace around the letter or shape using the marker (see B). The outline of your letter will be covered up when filling in the shape with embroidery.

C. *Fill in areas with turkey stitch.*

D. *Threads trimmed and ready to go.*

4. Turkey stitch throughout your shape (see C). Start by stitching over the marker line and then stitch back and forth until you can't see any felt under your loops. I tried to make my stitches similar in size, but don't worry if your stitch length is uneven; just make sure you leave loops long enough to create the shag length you desire. (My felt patches were so small that I didn't use an embroidery hoop.)

5. Use sharp scissors to trim the loops to create a shaggy appearance (see D). Be sure and brush the shag in different directions and trim any long strands. My fringe was ¼" (6 mm) long after trimming.

6. The felt will have fuzz on it from the trimming; clean it up with some tape or a lint roller.

7. Attach the patch to your bag using a blanket stitch around the edges or cross-stitch in each corner.

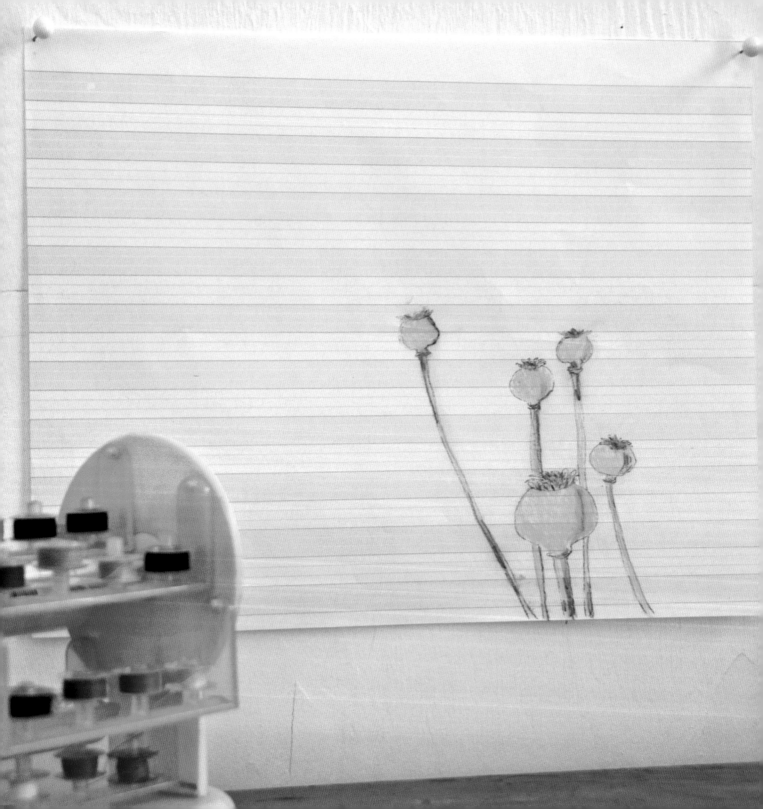

DRAWING WITH THREAD

PART 1: POPPY PODS

MATERIALS

- paper of your choice and size: vintage, wallpaper, scrapbook, etc. (if you choose rough paper, some of the design may not transfer into the grooves)
- poppy pod template on page 131
- colored pencil (or use watercolor, ink, or nothing at all)

TRANSFER METHOD

- photocopy transfer (see page 23)

THREAD/STITCH

- linen floss; single and double strand (I used an earthy green.)
- cotton floss; single and double strand in various greens (I combined two different greens for a different effect.)
- backstitch (see page 136)
- straight stitch (substituted chain stitch for card) (see page 139)

Thread can create and emphasize a line, shape, or shadow—it instantly creates an area of interest. I particularly love using it on top of another media for a collage effect. For this project, I wanted to use a simple sketch and freshen it up a bit; first with colored pencil and then with some embroidery. I've always had a soft spot for poppy pods. One of my favorite things to do is to sketch in the garden (there is a long history of this practice in art—Monet, anyone?). I also have a huge collection of vintage papers, and I thought the green stripe computer paper would make a nice backdrop for this drawing. I used the photocopy-transfer method so the drawing would have a printed look, making it appear more hand drawn and slightly uneven.

If you don't want to worry about mirror imaging the transfer, or don't like the look, a simple tracing method will work with this template.

A. *Use colored pencils to make the chunky shadows.*

TIP To avoid wrinkling the paper when you embroider, you may want to punch holes before you begin. Place the paper on a self-healing mat, corkboard, or a piece of cardboard, and use a pushpin.

1. Transfer the poppy image onto the paper in the size you want.

2. Color your poppies. I used a couple of shades of green and thought about what areas to fill in. I also made some of the shadows more freeform and chunky (see A).

3. For the embroidery, I randomly selected outlines to follow and shadows to emphasize. Keep in mind the overall balance of your piece—take time to step back and observe which areas need more emphasis. You could fill in one poppy of the bunch or outline a few of them (see B).

B. *Poppies stitched on muslin*

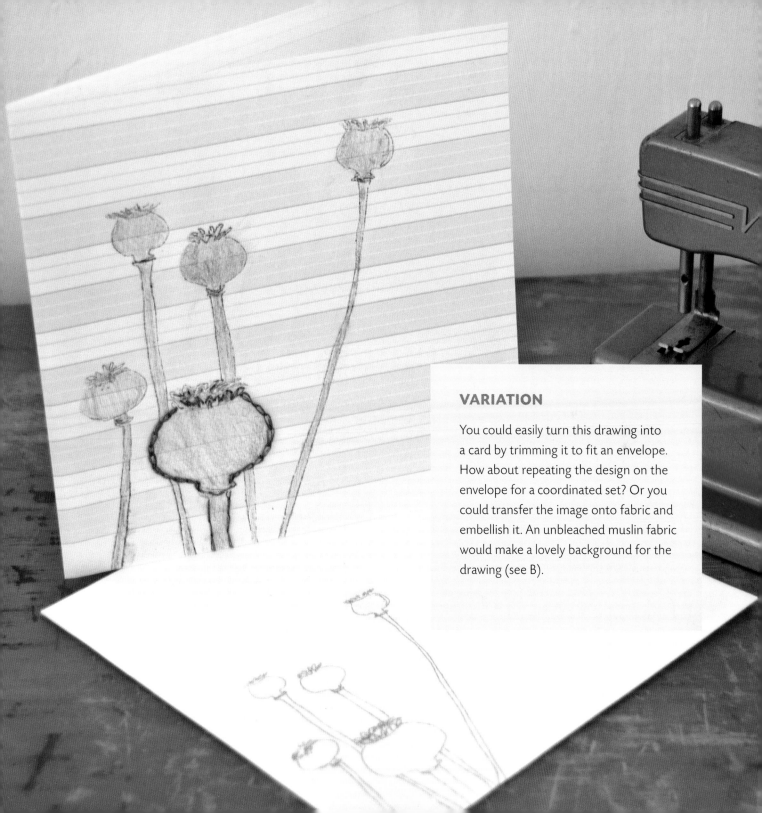

VARIATION

You could easily turn this drawing into a card by trimming it to fit an envelope. How about repeating the design on the envelope for a coordinated set? Or you could transfer the image onto fabric and embellish it. An unbleached muslin fabric would make a lovely background for the drawing (see B).

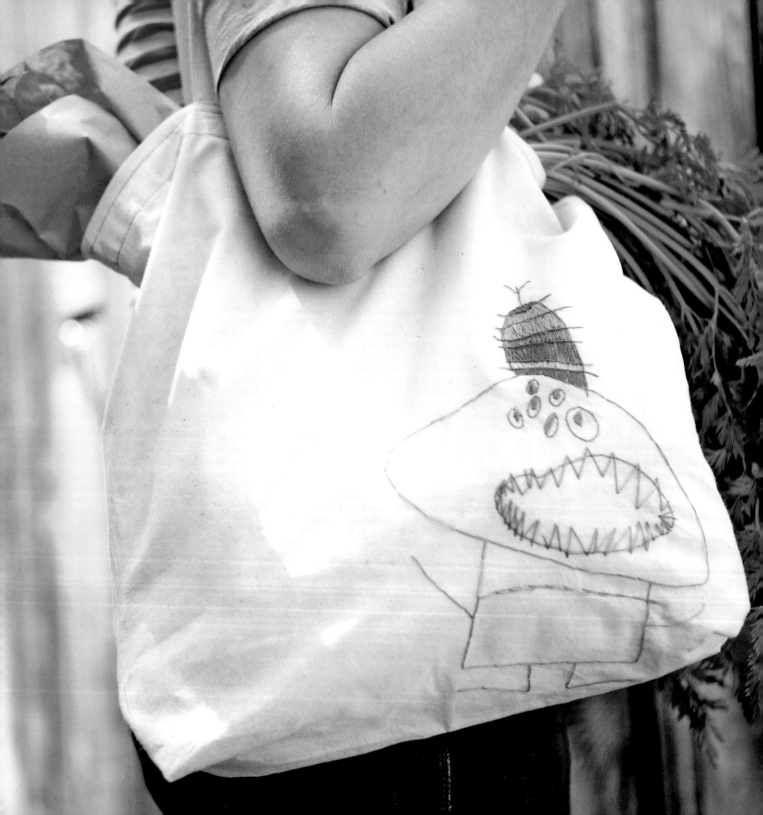

CHILDREN AS MUSES

PART 1: MULTI-EYED MONSTER TOTE BAG

with drawing by Andrea Corrona Jenkins's son Ezra, age 7

MATERIALS

- 14½" × 15½" (37 × 39 cm) tote bag *(many sizes available—use whatever you can find, or make your own)*
- child's drawing or Multi-eyed Monster template on page 131
- Optional: extra copies of the drawing and colored pencils
- Optional: lining fabric for the tote, sewing machine

TRANSFER METHOD

- iron-on transfer pen (see page 24)

THREAD/STITCHES

- cotton embroidery floss: double strand for outlining, triple strand for filling in the hat
- all-purpose sewing thread to match lining fabric and contrast thread to stitch lining to tote
- long backstitch (see page 136)
- straight stitch (see page 139)

I'm endlessly inspired by how sewing artist Lizette Greco uses her children's drawings in such a wonderful way (www.lizettegreco.com). I spent a summer in college teaching art to children, and I wanted to take all their drawings home. Embroidering a child's drawing adds a whole new texture and permanence to the work. I enlisted the help of Andrea and her son Ezra for this project. It was really hard to choose just one of Ezra's drawings, but I finally settled on the multi-eyed monster because I thought it would be fun to color in only his hat or his teeth.

65

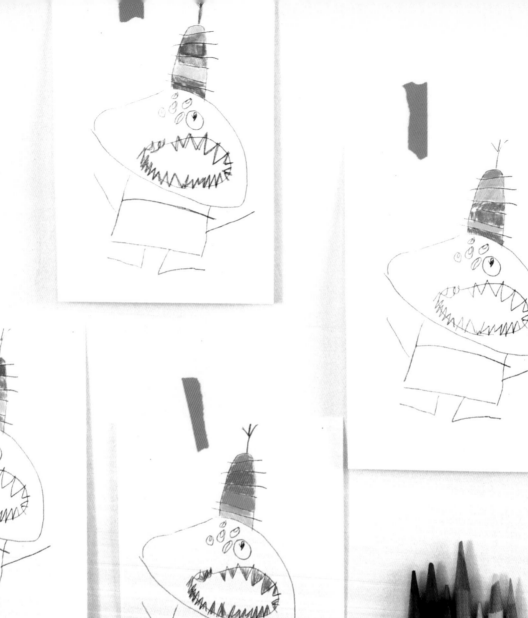

TIP This is one instance where the order in which you stitch the design can really help you replicate the way the child drew the piece. Be aware of which marks go over and under one another.

1. Determine the placement of the child's drawing or the template on page 131, and transfer the design.

2. Color the extra photocopies of the drawing to decide your palette. The original drawing was done with pencil, and I wanted to keep the graphite feel, so I used gray for an outline color. I then played around until I found colors that I wanted to use for the filled-in areas (see A).

3. Embroider around the outline of the monster (except for the hat) with long backstitches. I like the look of the long backstitch, as it mimics hand drawing. If you make the stitches more than ¾" (2 cm) long, you might have some puckering and increase your chances of snagging the stitches when the tote is used. Consider couching these stitches if they don't lay flat enough (see page 136).

4. Fill in the pupils of the eyes with straight stitches. Outline the mouth and then do the teeth, because they were drawn on top of the mouth outline in Ezra's drawing.

5. Color in the hat stripes using angular, slightly haphazard straight stitches to mimic a child's coloring. Use long backstitches to outline the stripes across the hat and then outline the hat (see B).

6. Take your tote to your nearest farmer's market and put it to use!

B. *Fill in hat areas with straight stitches.*

LINE YOUR TOTE

1. Cut lining fabric 1" (2.5 cm) wider and two times the tote, length, plus 2" (5 cm). For my tote the cut dimensions were 15½" × 33" (39 × 84 cm).

2. Fold the fabric in half across the width with right sides facing. Stitch each side using a ½" (1 cm) seam allowance. Do not turn right side out.

3. Fold 1" (2.5 cm) of the upper edge to the fabric wrong side; press.

4. Insert the lining into the tote, line up the side seams, and pin the upper edge in place every 2" (5 cm) or so.

5. Most tote bags have a double row of stitching at the top. Use the stitching as a guide to do the final stitching to attach the lining. I used contrasting red thread to add some interest.

< **A.** *Use colored pencils to try different colorways.*

ARTIST VERSION: PORTRAIT OF PAPA

by Amy Karol and Delia Jean Matern, age 6

MATERIALS

- two 9" × 12" (23 × 30.5 cm) pieces of lightweight muslin or cotton fabric *(avoid jersey or stretch fabric)*
- 9" × 12" (23 × 30.5 cm) piece lightweight fusible interfacing
- 9" × 12" (23 × 30.5 cm) piece fusible fabric
- Portrait of Papa template on page 132, or another child's drawing
- sewing machine
- quilting or darning presser foot

TRANSFER METHOD

- tracing with water-soluble pen (see page 22)

THREAD/STITCH

- all-purpose cotton sewing thread, various colors
- free-motion machine stitch (or darning stitch)

Amy Karol used free-motion stitching on white muslin to trace a drawing by her six-year-old daughter. You could even consider doing an abstract version of a younger child's scribbles. The finished artwork can be framed in a shadow box or behind glass. (See framing tips, opposite.) Thread drawing, as Amy likes to call this technique, is a wonderful medium for translating children's artwork. Free-motion stitching may look hard, but it's very forgiving and fun to do.

TIP If you don't have the free-motion stitching option on your sewing machine, don't let that stop you. You can render this drawing with hand embroidery only.

1. Have the child create a drawing on 8½" × 11" (21.6 × 27.9 cm) paper, or use Papa's Portrait template on page 132.

2. Press the fabric and then apply the fusible interfacing to the wrong side of one piece of muslin or cotton fabric to add stability.

3. Transfer the artwork to the stabilized fabric.

4. Consult your sewing machine manual and adjust your machine for free-motion quilting or a darning stitch. This involves lowering the feed dogs and changing the presser foot. Use your hands to move the fabric around as you stitch along the traced lines. The machine stitching looks best if you sew over the lines several times—the more, the better. (See the tip for free-motion stitching on page 68.) Change colors as needed. It took Amy about three one-hour sessions to stitch over the drawing (A).

5. Hand-embroider smaller details after the machine stitching is complete. This varies the thread weight and adds texture to the piece.

6. When you are finished, spray any visible pen markings with water to make them disappear. Press the piece carefully with a press cloth over the top to help ease out any puckers. Some puckering is normal and adds a nice texture.

7. Finish the piece by folding the raw edges to the back and press in place. To make a back, trim the second piece of muslin slightly smaller than the artwork and then apply the fusible fabric following the manufacturer's directions between the front and back piece, making a sandwich.

8. Frame behind glass or in a shadow box, if you like.

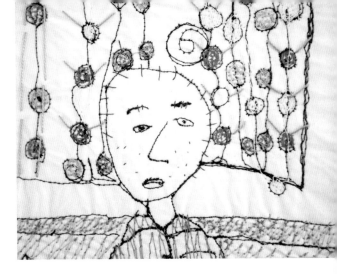

A. *Detail to show the stitching.*

FRAMING TIPS

A professional framer can help frame your finished piece. A shadow box with an open front can be used, or you can frame it behind glass with spacers to create depth so the fabric doesn't touch the glass. (See "Optional Frame" on page 83.)

Amy tacked the finished piece directly to mat board by piercing two small holes through the board and then catching a bit of fabric with needle and thread and tying a knot on the back of the board. Tape or other adhesives are not a good idea for attaching the fabric.

You may wish to save the original art-work—you could mount it to the back of the framed piece to make it even more special.

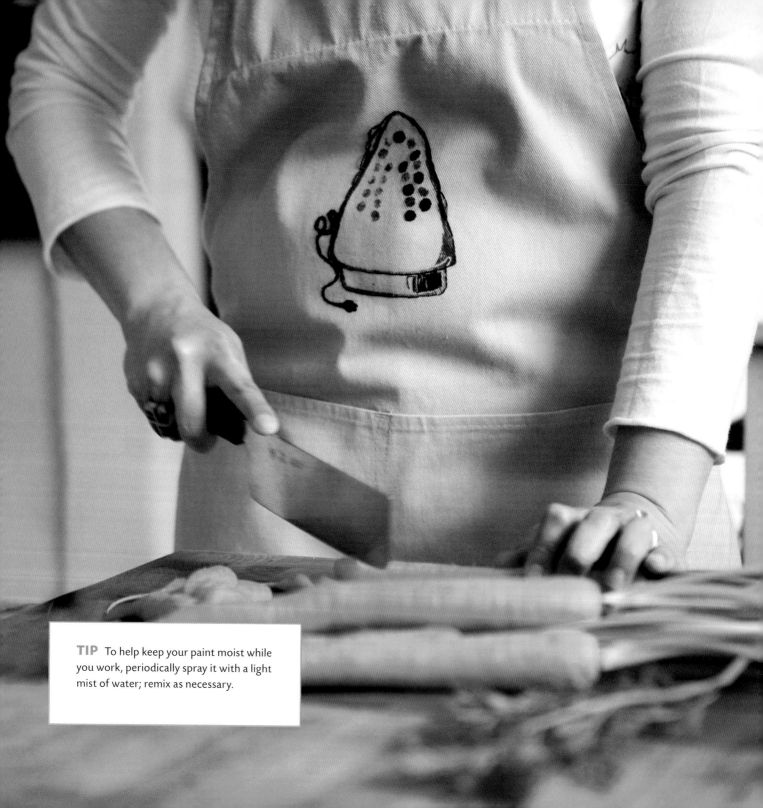

TIP To help keep your paint moist while you work, periodically spray it with a light mist of water; remix as necessary.

HAND-CARVED STAMP DESIGNS

PART 1: IRON APRON

MATERIALS

- apron
- 5" × 7" (13 × 18 cm) linoleum block
- iron template on page 131
- acrylic paint and small brush
- acrylic fabric medium
- set of linoleum carving tools
- ruler
- artist tape

TRANSFER METHOD

- tracing paper and pencil (see page 21)

THREAD/STITCHES

- cotton crochet thread, size 10, single and double strand
- backstitch (see page 136)
- straight stitch (see page 139)

I have made linoleum stamps for years and use them to make patterns within my paintings. While I adore commercially made stamps, there is something satisfying and wonderfully wonky about carving your own stamps. A stamp provides a quick and easy template, and designing one personalizes your project even more.

This iron stamp is from my arsenal of imagery, and I thought it would make a nice addition to an apron. I wanted something besides food-based images, and I thought using non-girly colors would be interesting. I used crochet thread because it has more texture than embroidery floss. The apron fabric already had quite a bit of texture, and I wanted to be sure the stitching was visible. I also chose to leave certain areas free of stitching to highlight the difference between the stamped and stitched areas. Alternately, it could be interesting to use contrasting colors for the stamp and thread or only stitch the steam circles.

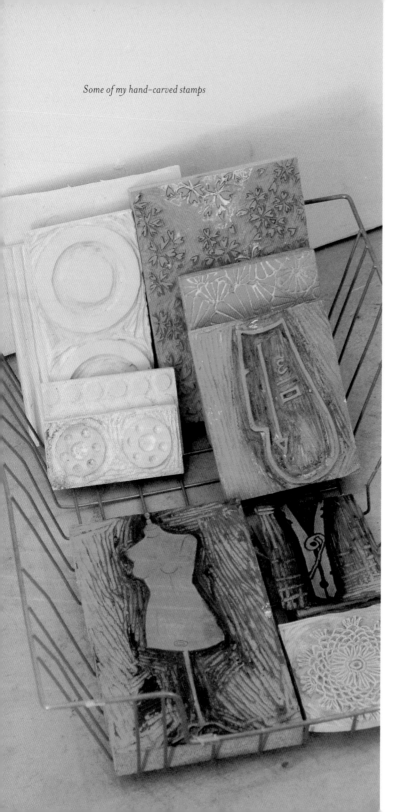

Some of my hand-carved stamps

1. Transfer the iron template to the linoleum block with pencil and tracing paper. (See "Rubbing with Tracing Paper and Pencil/Charcoal" on page 21.) Carve the block, removing the areas you don't want to print and leaving the image. Be careful around the cord—it's easy to cut through the narrow space.

2. Thin the acrylic paint slightly with water, or if you are using fabric medium, add the manufacturer's recommended amount and then paint a light coat of paint onto your stamp. Make sure you can't see the linoleum through the paint, but you also don't want the paint too thick and goopy or it will bleed off the design edges. Make a couple of test prints on paper to make sure you have the correct amount of paint and understand where the center of the image lies on the block. Wipe the block clean with damp paper towels before reapplying paint. If necessary, rinse the linoleum block thoroughly under running water and pat dry. Also make sure your paint stays moist.

3. Lay the apron on a flat surface and measure the front to find the center. Now that you understand where the center of your image resides on your

> **TIP** I like to use acrylic paint mixed with a fabric medium to stamp images; it will withstand washing very well. Fabric paint or a multi-surface ink pad will also work. Be sure to read the manufacturer's instructions about permanence—many fabric paints and inks require heat setting.

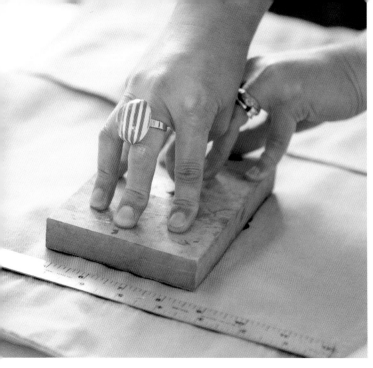

A. *Stamp the image onto the apron.*

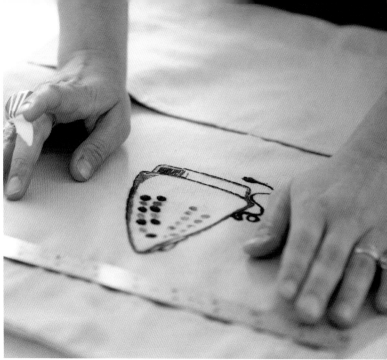

B. *Remove the stamp and tape markings.*

block, use tape to mark the upper and lower edges of where you want your block to be placed on the apron. (Use your block to determine the placement; just be sure it is clean and dry.)

4. When you are ready, add paint to your block and then firmly and evenly apply pressure throughout the block onto the apron (see A). Slightly rock the block back and forth, being careful to not actually move the block or the image may smudge and cause ghost prints. Remove the block (see B).

5. Allow the stamped image to dry. Thoroughly clean your linoleum block.

6. Embroider over the printed image to emphasize selected areas (see C).

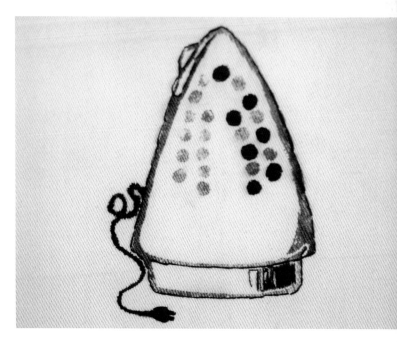

C. *Stitch over areas to accent the image.*

73

ARTIST VERSION: LEAF STAMP CARD

by Patricia Zapata

MATERIALS

- linoleum or cutting block about 3" (7.6 cm) square (This simple shape can also be carved from a soft white eraser.)
- carving tool, such as a V gouge
- leaf template, page 131
- ink pad in desired color (featured design uses silver)
- 5½" × 8½" (14 × 21.6 cm) sheet of card stock
- bone folder
- large needle with sharp point
- small piece of cork, foam board, or self-healing cutting mat

TRANSFER METHOD

- rubbing with tracing paper and pencil/charcoal (see page 21)

THREAD/STITCH

- three colors cotton embroidery floss, full strand
- straight stitch (see page 139)

This project proves that it's easy to make a basic, graphic, and compelling stamp. The stamp is simple, but with repetition the design becomes more interesting. The color and texture are added by embroidery, making them the main attraction of the card. Because the pattern is hand done, no two cards will be the same.

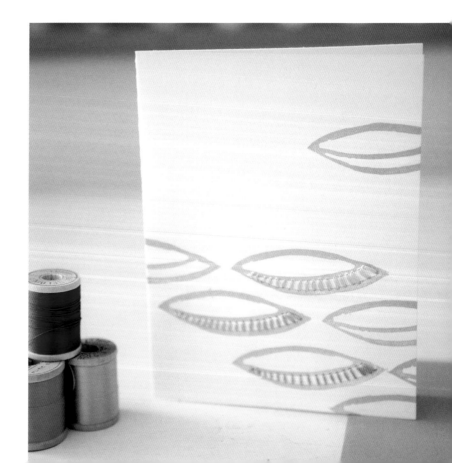

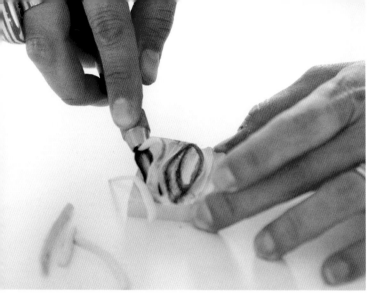

A. *Carve the image, removing only the background.*

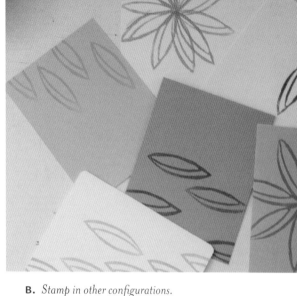

B. *Stamp in other configurations.*

1. Transfer the leaf image to the linoleum block. Carve the image, removing the background so only the leaf outlines remain (see A).

2. Fold the card stock in half resulting in a card 4¼" × 5½" (11 × 14 cm). Use the bone folder to flatten the crease.

3. Evenly print the stamp eight times to recreate the pattern shown here. Or try stamping the image in other arrangements (see B). Place scrap paper under the card to protect your work surface when stamping leaves that overlap the edges.

4. Unfold the card and place the front over the cork or cutting mat. Use the large needle to poke holes through the paper along the inner edges of the bottom crescent shape of three leaves. The holes should be evenly spaced about ⅛" (3 mm) apart.

5. Thread the needle with a full strand of floss. Start at one end of the first leaf, leaving the loose end on the inside of the card (catch the lose thread on the inside with the first few stitches). Use a straight stitch and sew vertically through the punched holes, until the crescent is filled.

6. The last stitch should end inside the card. Insert the needle through the back of several stitches to secure the thread; trim the thread end.

7. Using different thread colors, repeat steps 5 and 6 for the remaining two leaves.

> **TIP** For a neat finish inside the card, glue another sheet of paper over the back of the stitching. Then you can tape the thread ends to secure instead of weaving them through the stitches.

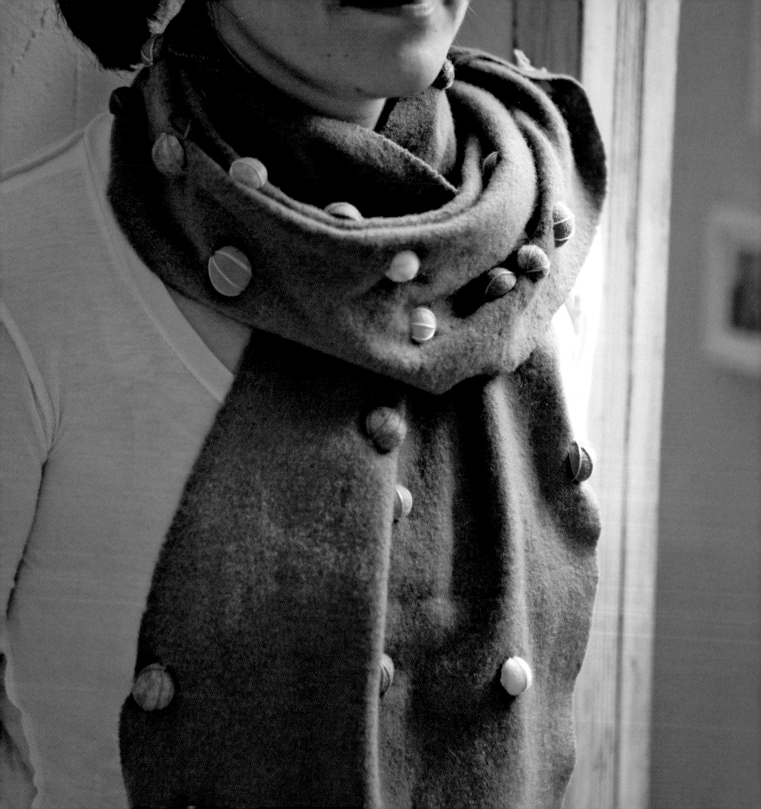

3D MENDING

PART 1: POM-POM SCARF

MATERIALS
- item to be mended
- felt balls (see "Resources")

THREAD/STITCH
- cotton embroidery floss, full strand, in coordinating (or contrasting) colors to your felt balls
- straight stitch (see page 139)

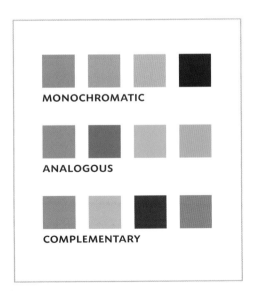

MONOCHROMATIC

ANALOGOUS

COMPLEMENTARY

I had a beautiful soft cashmere scarf that I put away one summer. When I pulled it out again for winter, it was littered with moth holes. I didn't want to throw it away because it was so comfy and I loved the color. So I threw it in a hot washing-machine cycle to felt it and keep the holes from getting any bigger. Then I used a bunch of craft felt balls to mend it. (Felt balls come in a variety of colors and sizes, and some have predrilled holes in them. It doesn't matter which you use for this project.) You can use this technique to repair small holes on almost anything as long as the material isn't too prone to fraying. Or just add balls for decoration to other accessories. I tried to use balls in colors that were harmonious but in different color families. You could easily use a monochromatic, analogous, or contrasting color scheme if you want. See some examples in the chart to the left.

Moths had eaten holes in my scarf.

1. Cut an appropriate number of felt balls in half. Don't worry if some aren't exactly in half; the variety of thickness adds interesting texture.

2. Place cut balls over the holes in your item; keep in mind the color placement. I worked with a simple parameter—I didn't want two balls of the same color next to one another. The cream balls coordinated with all the colors, and I had more of those, so I used them as filler.

3. Thread a needle with cotton embroidery floss and knot the ends together. Use your thumb to hold a half-ball over the hole. Bring your needle up on one side of the ball. Wrap the floss over the ball center and insert the needle on the opposite side; pull very tight. Bring your needle up about ⅛" (3 mm) on either side of where the needle last entered the fabric. Lay the floss back over the ball to the side of the previous wrap and insert the needle through your initial hole; pull tight again. You don't want the ball to shift or move. On the underside, run your needle around the strand of floss (as if you were tying a knot). This will prevent undoing your last stitch. Bring your needle back through the initial hole. Wrap the floss over the ball again and enter the fabric about ⅛" (3 mm) on the other side of the center stitch (see A). Pull tight and make a knot on the wrong side. I varied the orientation of my initial holes so that the balls look as if they were tied down on both their tops and bottoms. You could also secure them all in the same direction.

A. *Stitch the balls in place.* >

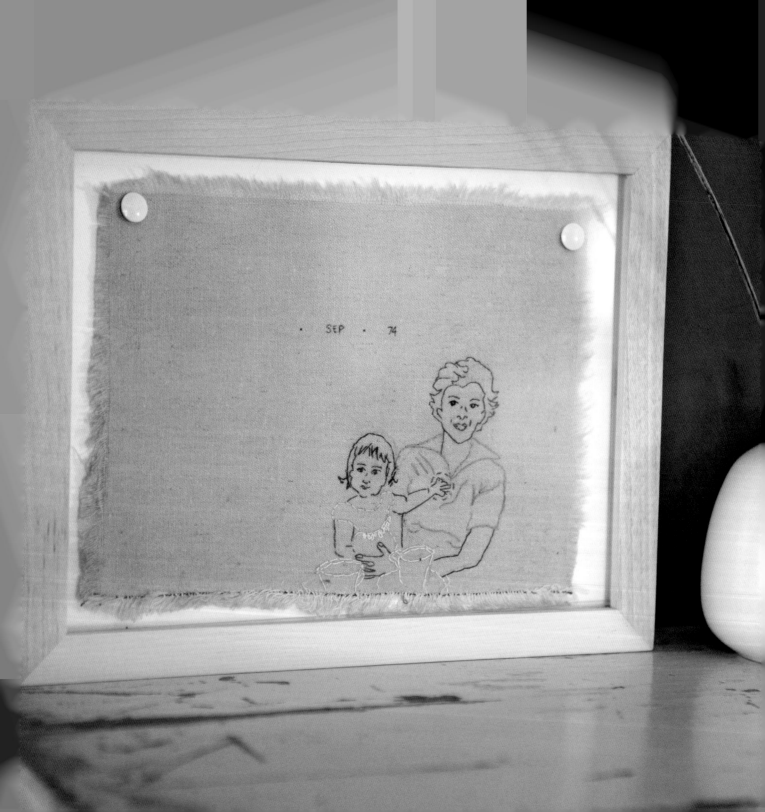

PORTRAITS

PART 1: "ME AND GRAM" PHOTO-BASED PORTRAIT

MATERIALS

- photograph
- 6" × 8" (15 × 20 cm) linen (or fabric in size you desire for the background)
- vellum or tracing paper
- fine-point pen or pencil
- permanent markers or other materials for adding drawn details

For optional frame you'll need:

- 8" × 10" (20 × 25 cm) frame, or frame that fits your piece
- mat board and pins
- artist tape
- pliers

TRANSFER METHOD

- tracing paper and pen or pencil (see page 20)
- wax-free transfer paper (see page 23)

THREAD/STITCH

- all-purpose sewing thread (this is good for embroidering small details, such as the eyes)
- backstitch (see page 136)

I have been doing embroidered portraits from photographs for years. I love how photographs translate when you stitch them. For this project, I chose a photo of me with my paternal grandmother, Shirley—this book is dedicated to her (see A, page 84). We had a very special relationship, and I think that's evident in this photo. I also added a few drawn elements in areas to add a contrast in texture. I wanted to include the date in the original photo, but I did not want to stitch it. I also wanted to emphasize how I'm grabbing her shirt (again without stitching, instead I used just a change in color). It would also be fun to paint or color in some areas before stitching.

For your project, choose a photo where the facial features are clear and with good light and dark contrast (this makes it easier to decide what to trace). You could omit facial features for a completely different effect. I chose a black-and-white photo, but you could easily use a color photo (or turn a color photo into a black-and-white image). The thread color you choose will also help determine the overall feel of your piece. I wanted to stay true to the original photo, so I used white, black, and gray threads. I also really liked the selvedge (finished edge) of my linen and wanted to keep that as the bottom of my piece.

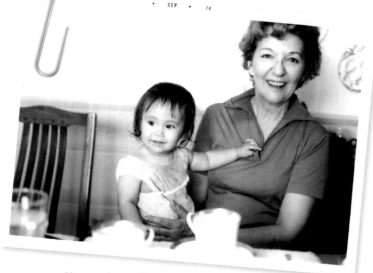

Photo used as a subject

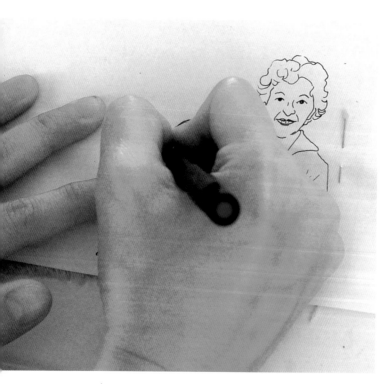

A. *Tracing the image to transfer the design.*

1. Trace your photograph using the vellum or tracing paper and a pen or pencil (I tend to use very fine-point pens for this). Think about what lines you want to include. Do not try and copy every detail, instead trace around large areas of light and dark. Remember to keep things simple, especially in the facial area.

2. I like to photocopy my tracing so I can adjust the size and so I have a backup image in case I'm unhappy with the transfer. For my project, I wanted to keep the embroidery the same scale as the photograph, but you can enlarge or shrink the image as you see fit.

> **TIP** Tracing over a photograph with a pen or pencil can cause dents in the image. If your photo is precious, make a copy for tracing.

3. Transfer your drawing to the fabric with wax-free transfer paper (see A).

4. Draw or paint some elements if desired prior to stitching the design.

5. Embroider the image by backstitching the lines. In small areas, I used very small stitches. In large areas, I use longer stitches.

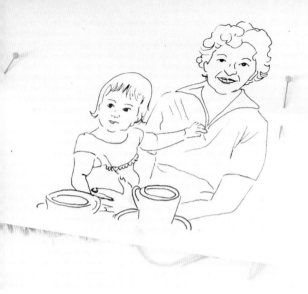

Pinning the paper in place to transfer image

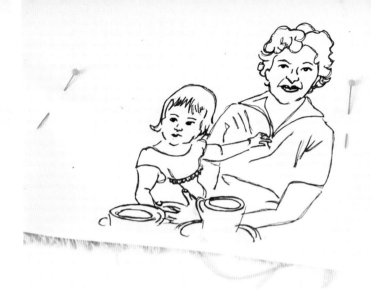

Use a different colored pen so you can see where you've already transferred

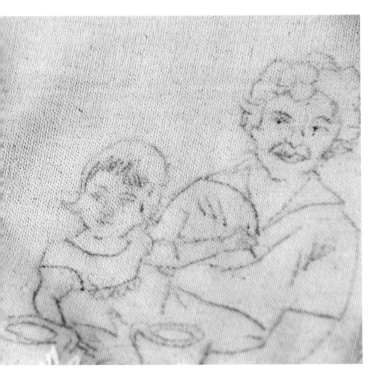

The transferred drawing

OPTIONAL FRAME

Mount your finished piece onto a piece of mat board that will fit in your frame. I used flat-head pins to pierce through the fabric and board. Bend the points of the pins on the back of the mat board with pliers, and then put artist tape over the points to secure them.

Remove the frame backing. Use spacers inside the frame to create a space between the fabric and glass. (See "Resources" on page 140.) You can also purchase a shadow-box frame. Clean the glass, insert your mat board, and close up the frame. It's also nice to use artist tape around the closure of your frame to keep dust and dirt out.

ARTIST VERSION: ILLUSTRATIVE PORTRAITS

by Betsy Thompson

MATERIALS

- 7½" × 8½" (19 × 21.5 cm) rectangle of 140-lb watercolor paper
- art paper in skin tones and hair colors
- a variety of collage materials: origami paper, wallpaper, scrapbook paper, buttons, pressed fabric, and vintage ephemera (old books, sheet music, maps), etc.
- illustrative portrait templates on page 131
- spray adhesive
- glue stick
- pencil
- hole punch
- sewing machine (or stitch by hand)

THREAD/STITCHES

- all-purpose sewing thread
- machine straight stitch
- running stitch if hand sewing (see page 138)

Betsy was reluctant to do a portrait project because she usually focuses on food items or scenes from nature. She and I discussed the many ways to capture the essence of a person, and I convinced her that a portrait didn't mean a photo-realistic representation of someone you know. In the end, only one of these is based on a real person, and yet they feel very personal. Betsy's templates can be easily altered to reflect your family and friends.

Before you begin, think about the person you are creating a portrait of. What color is her hair, eyes, and skin tone? Does he wear glasses or have a particular hairstyle? What are her interests or hobbies? Does he have a favorite pet, food, color, like to travel, or play a musical instrument? You can incorporate as much or as little of this information into the portrait as you like.

1. Choose your background. Use the watercolor sheet as a template and cut out a 7½" × 8½" (19 × 21.5 cm) rectangle. The background is a great place to incorporate some of the person's individual characteristics by using interesting fabric, paper, sheet music, maps, or anything else you can sew through.

2. Gather your elements. Trace the templates onto papers of your choice and cut out the body parts. For eyes, use a hole-punch to cut out two circles. Use scissors to cut out a half-circle for the mouth. Draw and cut out any other elements you would like to include in your portrait such as a hat, glasses, jewelry, hair ribbons, monogrammed initials, buttons, etc.

3. Secure the background to the watercolor paper with spray adhesive. If you don't want to use spray adhesive, use a glue stick to tack down the background—try and apply an even coat to avoid lumps and let it dry before stitching.

4. If you've never used your machine to sew paper before, try sewing on some scraps to get comfortable with the process; adjust your needle size and tension if necessary. Use contrasting or matching thread and sew around the edge of your background through the watercolor paper. Don't worry if the background doesn't fit exactly; you can trim the edges later.

5. Glue and then sew all the elements to the background in the following order: body, head, and hair. After sewing around the edge of each piece, feel free to add additional stitched details on the body or in the hair to give your portrait more texture.

6. Use the glue stick to adhere the eyes, mouth, and any other small details onto your portrait (see A).

7. If needed, trim the edges of your portrait, and you're done.

A. *Glue on small details.*

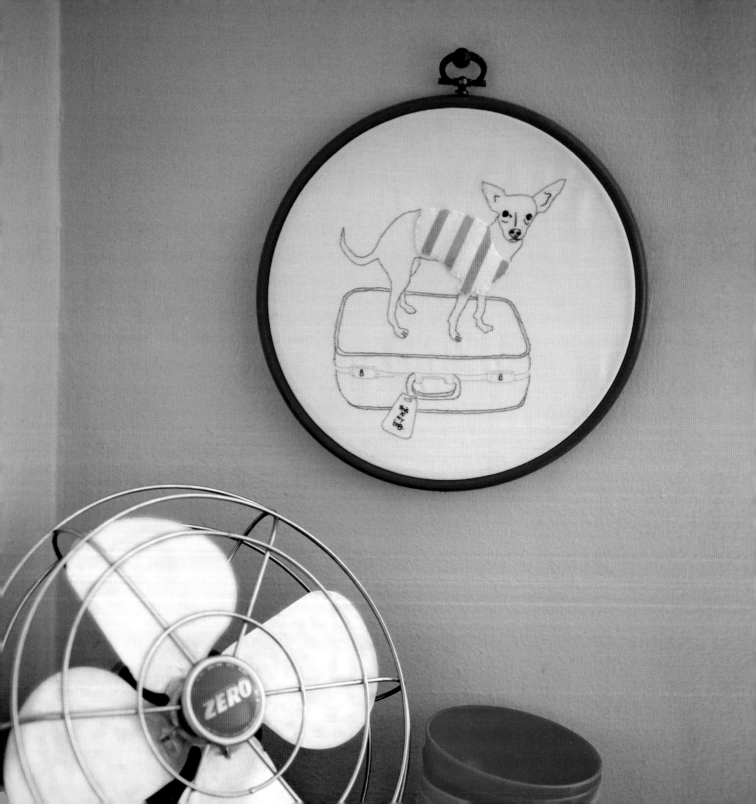

PET PORTRAITS

PART 1: WILFREDO

MATERIALS

- pet photograph or Wifredo template on page 131
- 12" (30.5 cm) square of white cotton, or other fabric, for background
- felt
- vellum or tracing paper
- fabric glue
- fine-point pen or pencil
- 8" (20 cm) diameter embroidery hoop

TRANSFER METHOD

- tracing with water-soluble pen (see page 22)

THREAD/STITCHES

- all-purpose sewing thread in various colors
- backstitch (see page 136)
- running stitch for appliqué (see page 138)

I love doing embroidered portraits of pets as much as (if not more than) humans. When I spotted an adorable photo of Wilfredo (who is Lisa Congdon's friendly Chihuahua; see Lisa's silhouette project on page 54). I knew I had to stitch it, and I knew it would make the perfect birthday gift for her. I wanted to include a bit more dimensionality, so I used a piece of felt to make an appliqué version of Wilfredo's sweater. (You can skip this step, or also add appliqué to another area, such as the suitcase.) Use the template provided or follow the guidelines in "Photo-based Portrait" on page 81 to draw a portrait of your favorite pet. I decided to use a vintage plastic hoop as the frame. You can purchase new plastic hoops in various colors or use a wooden hoop for a more traditional effect.

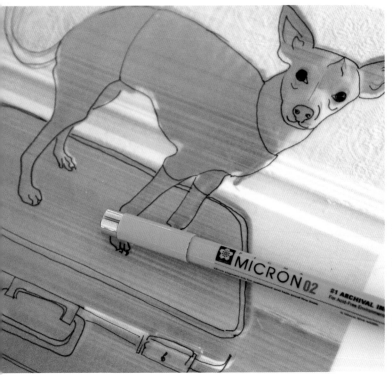
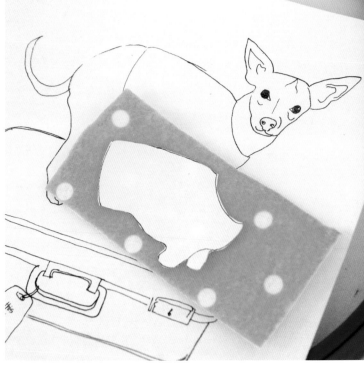

A. *Copy the sweater shape and cut from felt.*

1. Trace your photograph (see "Transfer 101" and "Me and Gram, Photo-based Portrait" for more specific instructions) or use the Wilfredo template and transfer it to your fabric.

2. Copy and cut out Wilfredo's sweater from the template and then use it as a pattern to cut a piece of felt (see A). Appliqué the felt sweater to the background fabric using a running stitch; refer to the template for correct positioning.

3. Place the fabric in the hoop and embroider the lines with backstitching. For very small areas (like the text in the tag) use tiny stitches.

4. Remove the portrait from the hoop and press the fabric.

EMBROIDERY HOOP FRAME

To use your embroidery hoop as a frame, dab small amounts of glue on the outer edge of the smaller inside hoop (see B). Reposition your fabric portrait over the inner hoop, add the outer hoop, and if your hoop has a screw, tighten it. Pull on your fabric edges to make sure it's taut and properly placed in the hoop (C). Place the hoop facedown on a clean work surface and then add a small amount of glue all around the backside of the inner embroidery hoop. Push the excess fabric down into the glue (D). Weight the fabric down and allow it to dry overnight. Trim any excess fabric as close to the hoop as possible (E).

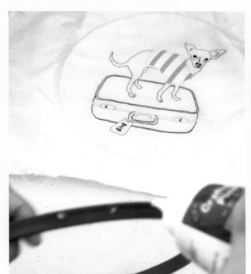

B. *Dab glue on smaller hoop.*

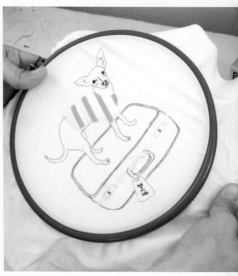

C. *Center image and pull fabric taut.*

D. *Press overhanging fabric into the glue.*

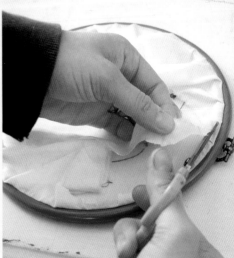

E. *Trim excess fabric.*

ARTIST VERSION: MORRAN PILLOW

by Camilla Engman

MATERIALS

- three 12" (30.5 cm) plain fabric squares (one muslin and two from coordinated color for the background)
- three 11½" (29 cm) squares of fusible interfacing
- two 6" × 57" (15 cm × 145 cm) lengths of fabric that coordinate with photo and background fabric (Camilla chose a pink print because of Morran's pink nose.)
- photo transfer paper that fits ink jet printer
- photo of cute pet (or person)
- trims to decorate with (lace, ribbon)
- sewing machine

TRANSFER METHOD

- iron-on transfer (see page 25)

THREAD/STITCH

- cotton embroidery floss, triple strand
- coordinating thread for your machine
- straight stitch (see page 139)

When I thought about pet portraits, Camilla Engman's faithful sidekick, Morran, came to mind. Camilla thought a round pillow would be the proper format to depict her pooch. To her, a round pillow seems obviously and perfectly impractical—it's all about luxury. With a nod to kitsch, Camilla created this wonderful poof of a pillow. Using a photo iron-on transfer ensures that your portrait is accurate, plus it makes it easy to embroider elements around the portrait. You could also embroider over the photo if you want. The sky is the limit here; you could add pom-pom trim or create a pillow portrait of your favorite child (in costume perhaps?). This is a project where over the top suits the bill!

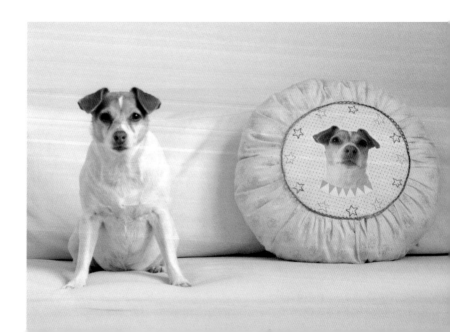

1. Find a cute photo to use.

2. Center and press the fusible interfacing onto the wrong side of the fabric squares (make sure the adhesive side of the interfacing faces the fabric).

3. Print the picture onto photo transfer paper—make sure it prints mirrored. Cut out your print, leaving a ⅛" (3 mm) border. Center the transfer photo facedown on the muslin and press hard with a hot iron for three minutes; cool and remove the backing paper. Trim the muslin leaving a ¼" (6 mm) border around the image.

4. Cut two 10" (25 cm) circles from the background fabric; Camilla used a plate as a circle template. Center and pin the transferred photo onto one background circle. Stitch the photo in place (a machine quilt stitch was used; zigzag stitch or blindstitch could be substituted as well).

5. The background circle is framed with ruching (gathered fabric strip). With right sides facing, sew the two strips together at one short end; press the seam open. Partially stitch the remaining short ends together by sewing only 1" (2.5 cm) from each edge, leaving a 4" (10 cm) opening in the seam. Press open the seam (the strip now forms a circle). Starting and stopping at the seam with the opening, machine-baste two rows of stitching on both raw edges, ¼" (6 mm) and ⅜" (1 cm) from the edge; don't backstitch and make sure to leave long thread tails.

6. Fold the strip in half crosswise, aligning the seams, and press the folds. The seams and pressed folds

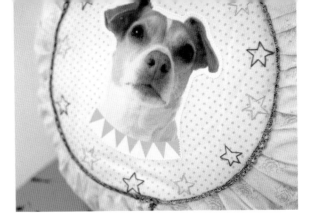

A. *Add trim and embroidered details.*

will divide the strip into quarters. Fold the background circles in half horizontally and vertically and crease the edges (or mark with a pin) at the folds to divide the circumference into quarters.

7. With right sides facing, align one edge of the fabric circle with a background circle; match and pin the pressed folds and seams to the marks on the circle edge. Grasp two of the long thread tails and pull to gather the fabric around the background circle. Adjust the gathers evenly and pin in place. Stitch with a ½" (1.3 cm) seam allowance. Repeat for the other background circle. Turn right side out.

8. Now it's time for the fun part—decorating. Camilla added silver lace around the background circle. And since Morran is such a star she added embroidered stars (see A). Think about your pet and what makes him special, and then add appropriate images to decorate your pillow.

9. When you are finished decorating, add fiberfill through the opening in the ruched edge. Blindstitch the opening closed and you have your poof. If you make a larger pillow it could double as a pet bed!

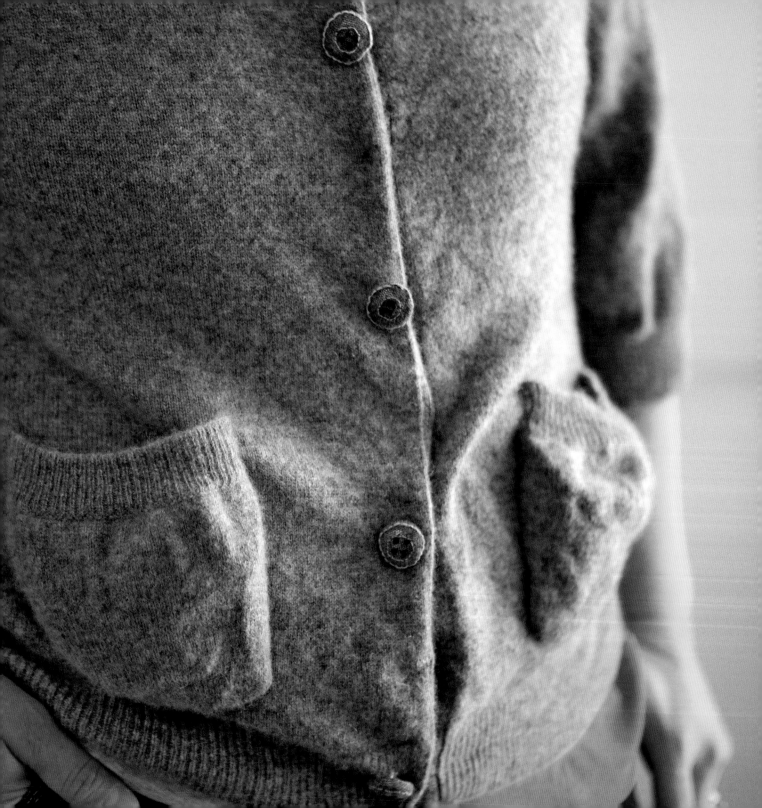

FABRIC-COVERED BUTTONS

PART 1: BUTTON BUTTONS

MATERIALS
- fabric
- button buttons template (optional) on page 133
- 7/8" (2 cm) covered-button kit (smaller and larger also available)
- water-soluble pen or fabric-marking chalk/pencil

TRANSFER METHOD
- refer to "Transfer Methods 101" on page 20 to determine which method will work best for your fabric

THREAD/STITCHES
- cotton embroidery floss, five colors plus black; double strand for outside line, single strand for inside line, triple strand for French knots
- all-purpose thread to sew buttons onto garment
- backstitch (see page 136)
- French knots for the faux holes on the button (see page 137)

I'm a sucker for a basic cardigan, and I loved this gray one, but it came with uninteresting snap closures. I had a covered-button kit lying around and some extra gray sweater material, so I thought it would be fun to mimic a button with embroidery knowing that it would end up being a bit uneven and look handmade. I purposely didn't use a template so I could enhance this effect, but I provide one here for your use. Each button is a different color, but you could make them all match (or vary from light to dark in one color).

There are so many variations and options for this project. You could also make a ring, hairclip, or pushpins. How about using patterned fabric and embroider over part of it? Embellished buttons are so much fun.

Buttons made into a ring and hairclip

A. *Fold in fabric edges, or baste edges together.*

B. *Place assembled button in rubber guide and push pieces together.*

1. Use the pattern provided with your button kit and cut out fabric circles to embroider. I used fabric-marking chalk to mark the button design placement because the pattern allows for a lot of extra material.

2. Depending on your fabric, transfer the template if you so choose. If you use sweater material, you might need to use a permanent marker.

3. Embroider the faux buttons or stitch a design of your choice. Because the circles are so small, I held them in my hand while stitching.

4. Make the buttons. Work on a hard, clean, and flat surface. Place your embroidered piece facedown, center the metal button front over your design, and tuck the fabric edges inside the button. Because I was using sweater material, I basted the back closed to keep the material from sliding around (see A). Place the button backing firmly in place over the button front. Insert this button "sandwich" into the rubber guide and firmly push down using your thumb and the plastic presser included in your kit (see B).

5. Stitch the buttons onto your garment, onto a hairclip, or using a pair of pliers, pull the little hoop off the back and glue it onto a ring blank or large pushpin. Once you start making these, you'll find all kinds of places to put them.

ARTIST VERSION: FRUIT AND VEGGIE CROSS-STITCH
by Frosted Pumpkin Stitchery

MATERIALS

- 8" (20 cm) square of 18-count linen
- corn, apple, pineapple, and pear cross-stitch templates on page 135
- covered-button kit: designs fit a 1" (2.5 cm) button perfectly

THREAD/STITCHES

- all-purpose sewing thread to sew on buttons
- cotton embroidery floss, various colors, double strand
- cross-stitch (see page 137)
- backstitch (for mouths) (see page 136)

An embroidery book just wouldn't be complete without a cross-stitch project. I asked the talented Amanda Jennings and Ashleigh Gilberson of Frosted Pumpkin Stitchery to make some fruit and vegetable–inspired patterns to turn into fabric-covered buttons. Once complete, you could sew them onto practically anything (or also make rings, hairclips, etc.). These cute buttons are almost good enough to eat!

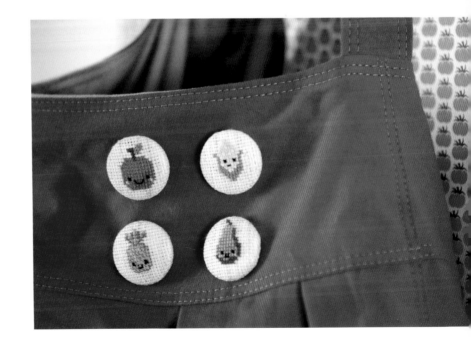

1. Place your fabric in an embroidery hoop and follow the templates to cross-stitch the designs.

2. Follow the process in step 4 on page 94 to make your buttons.

3. Find the perfect use for them (kitchen magnets, anyone?).

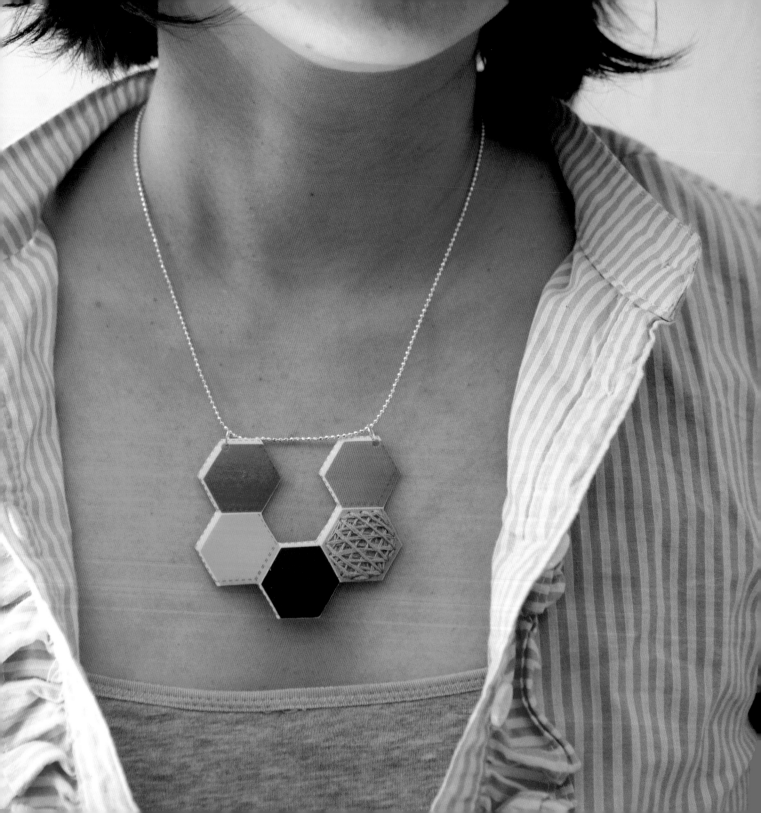

SHRINK AND STITCH IT!

PART 1: HEXAGON NECKLACE

MATERIALS

- shrink-plastic material for ink-jet printers (if you don't want to use your computer, substitute white or clear plastic and draw the design)
- permanent markers (optional)
- hexagon template on page 133 or for download at http://qbookshop.com/downloads/Knot-Thread-Stitch.html
- computer and ink-jet printer
- ¼" (6 mm) hole punch
- ⅛" (3 mm) hole punch
- clear matte or glossy fixative spray
- jump rings (optional)
- pliers (optional)
- silver chain (optional, you could make a cord with crochet thread, or slip it on a necklace you already own; see "Resources")

THREAD/STITCH

- embroidery floss (any would work, I tried a full strand of cotton, size 3 pearl cotton, variegated, and metallic)
- straight stitch (see page 139)

Do you remember shrink plastic as fondly as I do? I loved to sit next to the toaster oven and watch them curl, shrink, and come out thicker and cuter than when they went in—it was magic. I thought combining this amazingly versatile product with some stitching could be really fun and cool. I wanted to make something that was distinctly "adult" for one project as well as something that would be good for children (or for the kid in all of us). And, in case you wondered, shrink plastic is still magic to me.

1. If you have and are familiar with vector-editing software, scan or download the hexagon template. Add the desired colors and patterns to the hexagon shapes. In my version, I filled in the shapes slightly askew for interest and added a dotted line around the outermost edge of the hexagons. Then print the image onto the ink-jet shrink plastic. If you don't want to color them with your computer, print out a blank template onto shrink plastic and color it with permanent markers. You can also trace and color the hexagon design directly onto white matte shrink plastic.

2. Using the ⅛" (3 mm) hole punch, make three holes along each edge of the outer hexagons.

3. Use the ¼" (6 mm) hole punch to make holes at the necklace upper right and left for the jump rings or chain to go through.

4. Follow the manufacturer's instructions to shrink your necklace (each manufacturer has slightly different heat settings, suggestions for surfaces to shrink your piece on, and time guidelines). I recommend staying next to your shrinking piece; they tend to curl, and you don't want them to stay that way. I had wooden chopsticks at the ready to keep them from curling back on themselves. You can also flatten them while they are still warm after removing them from the oven. Wear an oven mitt or use a towel when flattening—they are really hot!

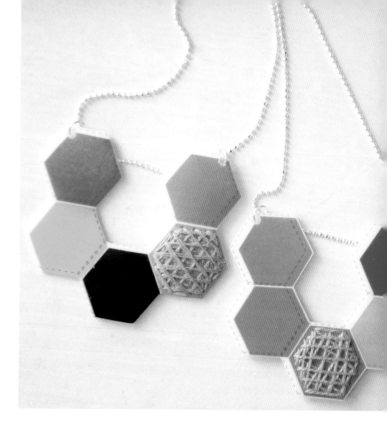

5. Once it has cooled, spray your necklace with a matte (or glossy) fixative spray to seal the ink (follow the manufacturer's instructions).

6. Stitch over the hexagon using the holes along edges with embroidery floss. I worked horizontally, vertically, and diagonally until the thread was really dimensional. I used thread that matched the printed colors, but you could use lighter, darker, or contrasting thread.

7. If desired, use pliers to add jump rings to the upper left and right holes. Slide your necklace onto a chain and wear it with pride.

ARTIST VERSION: LION AND BIRDIE ZIPPER PULLS AND KEY CHAINS

with illustrations by Susie Ghahremani

MATERIALS

- clear shrink-plastic material (could use any color)
- zipper pull and key chain templates on page 133
- 320-grit sandpaper (optional)
- colored pencils and/or permanent markers
- fine-tip permanent marker
- ¼" (6 mm) hole punch
- ⅛" (3 mm) hole punch (If you're using templates at their original size, use an eyelet-setting punch to make holes wherever you want.)
- artist tape (optional)
- jump rings
- key ring or lanyard clip for zipper pull (see "Resources")

TRANSFER METHOD

- tracing with permanent pen and colored pencil (see page 20)

THREAD/STITCHES

- cotton embroidery floss, double strand
- backstitch (see page 136)
- turkey stitch (see page 139) for lion (uncut)
 and whipstitch or blanket stitch (see pages 136 and 139)

How could you not love Susie Ghahremani's work? She is the force behind www.boygirlparty.com and illustrator of some of the cutest animals around. Susie graciously agreed to let me turn a couple of her drawings into miniature adornments with stitched elements. They make perfect key chains or zipper pulls, but I'm sure you can think of more uses for them.

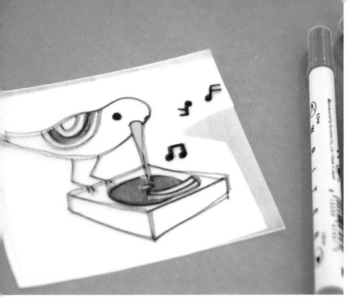

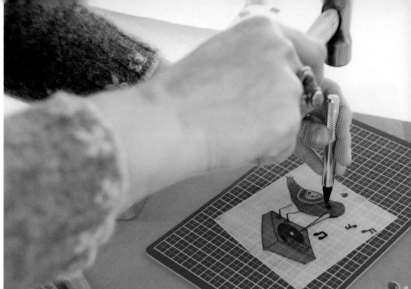

A. *Color the major shapes.*

B. *Punch holes around the design.*

1. If you want to color your design with colored pencils, you will need to sand the plastic; pencil won't stick to an unsanded surface. This isn't necessary for permanent markers, but I like the frosted effect the sanding provides, and the sandpaper's tooth makes the colors look more vivid. In some of my test pieces, the permanent-marker colors on unsanded plastic were more likely to scratch off after shrinking.

2. Place your plastic over the templates (use artist tape to hold them in place) and color the major shapes (see A). Outline the color with a fine-tip permanent marker or black color pencil.

3. Use the ¼" (6 mm) hole punch to make holes at the top of your pieces.

4. Use the ⅛" (3 mm) hole punch to make holes around the edge of the lion's mane, (or just across the top of his head) and in the bird wings

(see B). If you keep the animals in their square and circle shapes, use the ⅛" (3 mm) punch to create holes around the shape edges (this is optional, of course, but it looks nice to stitch around your edges too).

5. Follow the manufacturer's instructions and shrink your plastic. Monitor the process and flatten the shapes as needed while they are still warm (see "Hexagon Necklace," step 4).

6. Once cooled, embellish with embroidery. Use the turkey stitch for the lion's mane but leave the loops uncut. Backstitch the bird wings and either blanket stitch or whipstitch around the outside of the shapes.

7. For a key ring, add a jump ring and then place on the ring. For a zipper pull, slip the piece onto the lanyard, and then place on your zipper; ta da!

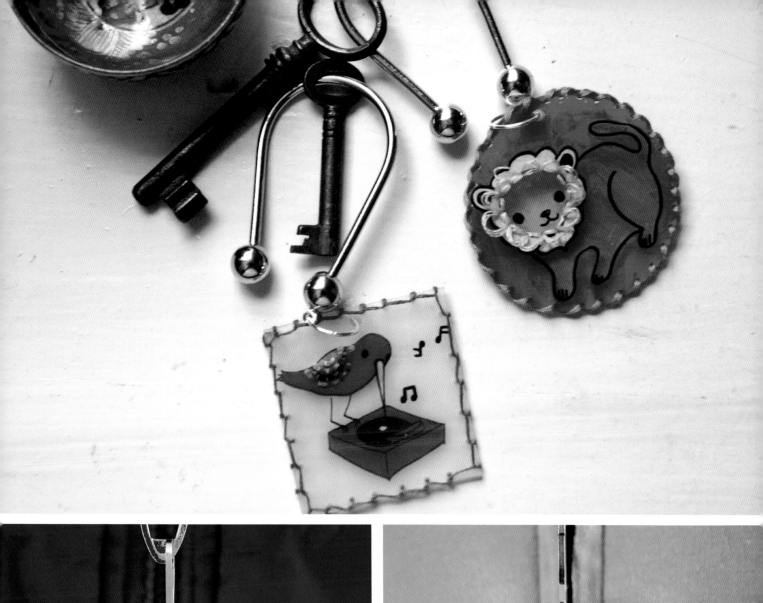

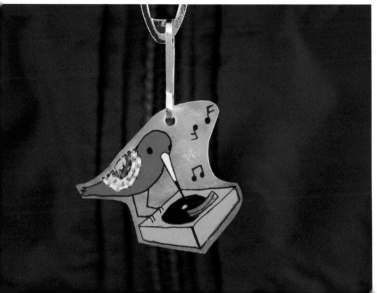

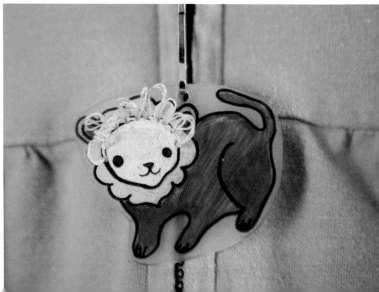

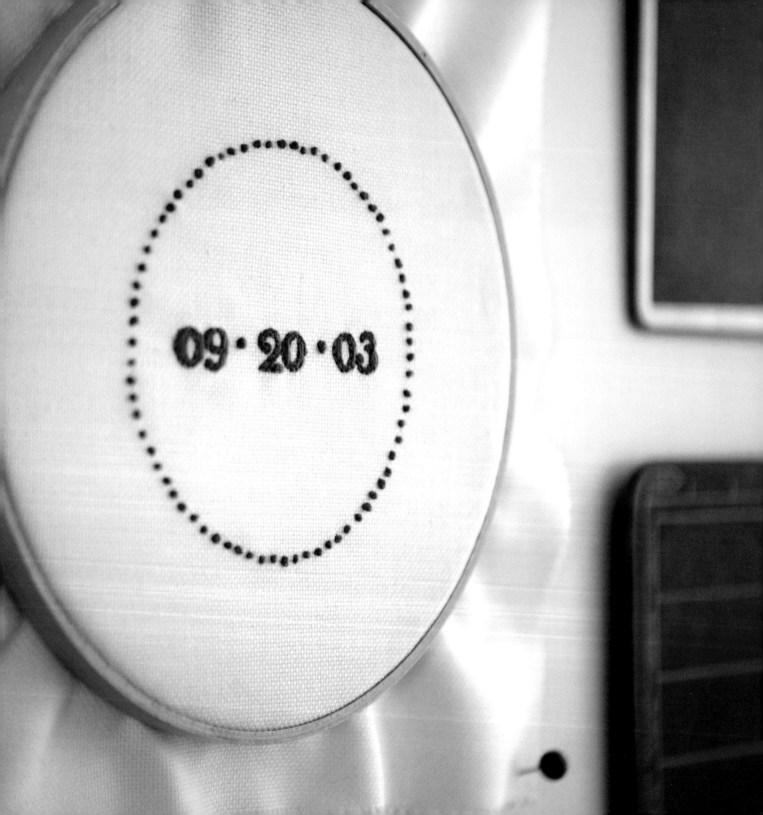

MODERN COMMEMORATIVE SAMPLERS

PART 1: ON THIS DATE

MATERIALS

- 11" (28 cm) square Hardanger/ Oslo linen (I pinked the fabric edges so they would look nice in the hoop.)
- 8" (20 cm) embroidery hoop (to embroider and as a frame)
- ruler
- optional: pinking shears

TRANSFER METHOD

- iron-on transfer pen (see page 24)

THREAD/STITCHES

- cotton embroidery floss, triple strand
- backstitch to outline (see page 136)
- French knots (see page 137)
- straight stitch to fill (see page 139)

I'm really drawn to traditional samplers. I have books that have examples from the early 1600s. I truly love the idea of stitching practice pieces and particularly admire the ones that also commemorate a name or date.

My husband and I decided to marry in 2003 after twelve years together. I designed our stationery around the date of our wedding, September 20, 2003, placing the date in a dotted circle (see page 105). I wore a 1950s rose embroidered cocktail dress that had peach, chartreuse, and green roses and leaves, so those became the colors of our wedding. I'm still proud of the simplicity and character of my design and have always wanted to stitch it—I finally did. I hope this project inspires you to commemorate a date significant to you: a birth, wedding, graduation, etc.

together with their families

LISA & DIETRICH

REQUEST THE PLEASURE OF

YOUR COMPANY

AT THEIR WEDDING

09-20-03

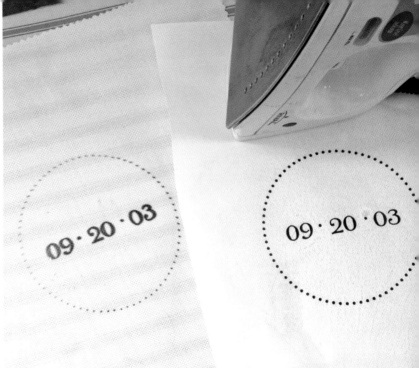

^ *Computer print out—use iron transfer pen on back to copy your design.*

^ *After ironing, the image is permanently transferred to your fabric.*

1. Use your computer to print out your date in the desired font size. If you have graphic software, you can draw a circle or any other shape around your date. You could also simply handwrite or draw your date. You could embellish it in a multitude of ways as well.

2. If using a print out, flip it over and trace it with the iron-on transfer pen on the backside. Add dots following the circle (if you didn't print a circle, use a plate or coffee can as a guide to draw a circle around your date). My dots were spaced ³/₁₆" (5 mm) apart. Transfer the design to your fabric using your iron on a high setting.

3. Place your fabric in a hoop. I used an 8" (20 cm) hoop that also became the frame. Use a back-stitch to outline your numbers, a straight stitch to fill in your numbers, and French knots for the dots around the circle.

4. When the embroidery is complete, readjust the fabric to make sure it's taut and centered in the hoop, then hang up your piece and remember your date fondly.

< *Our wedding invitation was the inspiration for this project.*

ARTIST VERSION: "66 YEARS"

by Heather Smith Jones

MATERIALS

- 10" (25 cm) square of hot press watercolor paper
- pencil
- watercolor or other paints
- cotton muslin, or any fabric scraps
- gathered materials: photos, clip art, ephemera, charms, stickers, etc.
- optional: stamps (see page 71 for how to make your own)

TRANSFER METHOD

- trace photos or materials as desired using the methods explained in "Transfer Methods 101," or simply draw and stitch as desired

THREAD/STITCH

- freeform! Use any type and color of thread, and any stitch you like
- chain stitch (see page 137)
- detached chain stitch (see page 137)
- double row of running stitch (see page 138)
- running stitch (see page 138)
- straight stitch (see page 139)

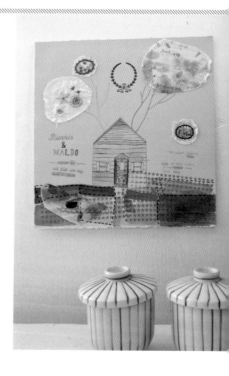

Heather makes wonderful and beautiful mixed-media artwork that gives a sense of personal narrative, so I knew she'd be the perfect one to ask to do a commemorative piece. Heather decided to commemorate her paternal grandparents who had an amazing life together and were married for sixty-six years before their passing in 2010. Memories of spending childhood summers with them directed the choices for imagery and text. The project incorporates drawing, painting, printing, and stitching.

Her project encourages you to tell a story or recognize an important person in your life. Feel free to explore other materials or use fewer details or materials to make your version. Consider how you want to celebrate the people and if specific materials lend themselves to those ideas, thoughts, or memories. Gather things that are meaningful to you to create your commemorative sampler.

1. Once you have an idea in mind, draw a central image and think about what it represents (in Heather's piece, this is the house). Add as much detail as you desire. Then draw or write supporting elements that surround the main image. Tell the person's (people's) story through pictures and writing, as in many traditional samplers. Think about how you can condense a larger narrative into a simple image or phrase.

2. When the composition is drawn, add watercolor shapes or areas to add focus and create interest in the piece. Let the paint dry. Stamp images as desired on open areas of the paper and think about layering images over the watercolor. In this piece Heather incorporated letterpress stars and a wreath. The star pattern works as a solid area of color.

3. After you have completed painting and stamping, it's time to embroider. Secure the fabric in an embroidery hoop, make stitch marks, shapes, images, or words using stitches you know, or practice stitches you want to learn. When you are finished stitching, tear or cut the fabric scraps into desired shapes and attach them to the paper using glue or stitching. Think about how you can use these fabric scraps as a layering tool—they can emphasize as well as hide areas.

4. When complete, look at the overall piece and make any adjustments. What image, word, or area of the artwork needs to be emphasized? Do you need a bolder stitch in a particular section? Does an area need more watercolor paint? Is the piece unified? Work until you feel your piece is complete.

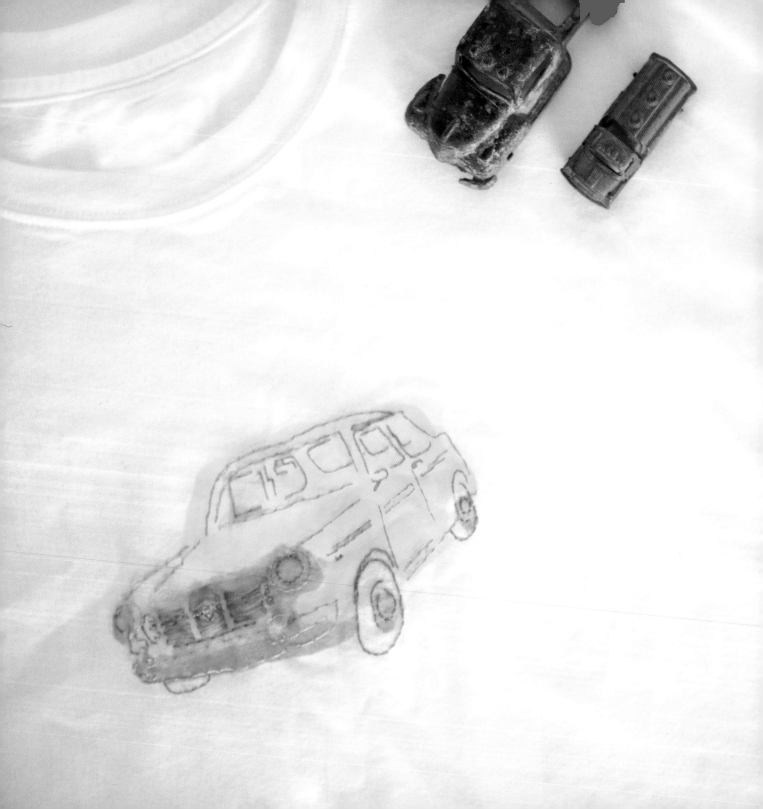

T-SHIRTS

PART 1: AUSTIN AMERICAN TEE

MATERIALS

- prewashed white cotton T-shirt (substitute any color and adjust paint and thread color as needed)
- fabric paint or acrylic ink in at least two colors (more if you want to mix)
- paintbrush (either bristle or foam)
- paper plate or palette for mixing paint or ink
- two copies of the Austin American template on page 134
- cardboard (little smaller than T-shirt front)

TRANSFER METHOD

- tracing with water-soluble pen (see page 22)

THREAD/STITCH

- cotton embroidery floss; triple strand for the tires and double strand elsewhere
- metallic floss; silver, double strand for headlights, bumper, and car emblem
- French knot (emblem center) (see page 137)
- running stitch (see page 138)

Would you embroider a man's T-shirt? Oh, why not. I wanted to decorate a T-shirt that my husband might actually wear. One of his first cars was an Austin American, and when I saw a photo of it, I just about died; it was such a cute car! Inspired by silk-screening, I thought it would be fun to make a somewhat messy print, you know that cool thing that happens when the registration is slightly off, creating askew lines. The stitching serves as a final embellishment.

A. *Place template inside shirt.*

B. *Paint the body; no need to be careful.*

1. Place your template inside the shirt, figure out the placement (see A), and then pin to secure the template in place (optional).

2. Insert the cardboard behind the template so your paint or ink won't bleed through to the back of the shirt.

3. Mix your paint if you want a custom color. I made a lemon yellow by adding white to yellow paint. My husband's car was yellow, but red or blue would be great too.

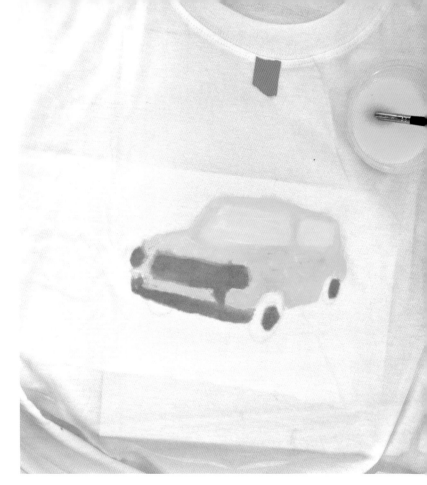

4. Paint the car's body using a larger brush and dabbing the paint (see B). As the fibers in the shirt get saturated the painting will become easier. Remember that you want this to be messy—go outside the template lines and don't completely fill in some areas. Let the paint dry.

5. Mix a dull gray color (you could use metallic, or a contrasting color if you want). Paint the bumper, hubcaps, and grill, continuing with the messy method (see C).

6. Carefully remove your template, which will be soaked with paint (keep the cardboard in place to assure that no paint leaks through to the back). Let the paint dry overnight.

7. Heat-set your image with an iron.

8. Position the remaining clean template underneath the painted area and trace the image outlines. Remove the template.

9. I began embroidering the tires with metallic thread and then moved on to the rest. Now it's ready to wash and wear! (Wash this shirt inside out on gentle cycle to ensure the longest life possible.)

C. *Add gray details.*

TIP Set your iron on the hottest setting that your fabric will tolerate. Move the iron over the painted area for 2 to 4 minutes.

ARTIST VERSION: BIRDS IN THE SKY AND LET'S GO FLY A KITE T-SHIRTS

by Christine Castro Hughes

Christine claims that she has long found inspiration in the ever-changing clouds in the sky, and she wanted to create complementary mom-and-kid T-shirt designs using clouds as a common theme. The child's tee represents the late afternoon sky, and the mom's tee represents when the sun goes down—they go together, but don't match completely. Christine incorporated the use of freezer-paper stencils—a great way to print clean shapes onto T-shirts. Her graphic clouds with kite and bird accents really epitomize fun—I can almost feel the breeze.

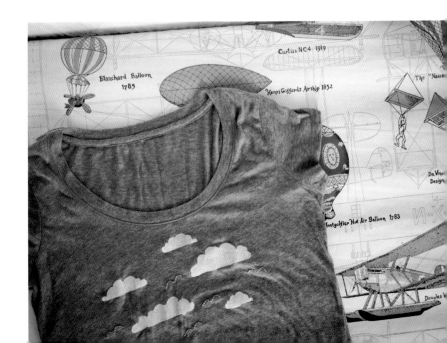

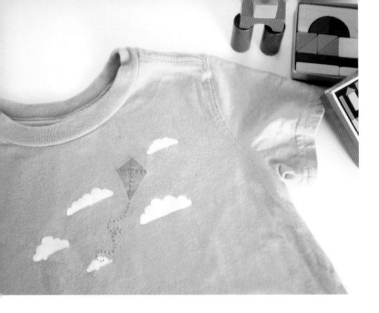

1. Photocopy the template on page 134 to fit the space on the T-shirt. Cut a piece of freezer paper slightly larger than the template. Place the freezer paper glossy side down over the image and trace with a pen.

2. Place the freezer-paper tracing on the self-healing mat and use the utility knife to cut out your design. The portions of the design you remove are the parts that will be painted.

3. Preheat iron to medium-high heat and turn off the steam. Press the T-shirt to remove any wrinkles.

4. Position the stencil, glossy side down, about 3" or 4" (7.5 or 10 cm) from the neckline and center horizontally. Press the stencil onto the shirt (the wax on the paper fuses to the shirt, but also allows for the template to be easily removed). Check to be sure all parts of the stencil are fused to the fabric.

5. Place the cardboard inside the T-shirt to prevent the paint from leaking through to the back.

6. Pour 1 or 2 tablespoons (15 or 30 ml) of paint onto a paper plate or artist's palette. Load your stencil brush with paint; dab any excess onto a paper towel. This will help ensure a smooth, even coat and prevent the paint from bleeding under the stencil edges.

7. Paint one coat at a time, moving from left to right and using downward, even strokes. Wait for the paint to dry before adding additional coats. Use a hair dryer to speed up the drying if desired.

8. Let your design dry for 12 hours. (Follow the manufacturer's instructions for your fabric paint.)

9. Once your paint has fully cured, start from one corner and carefully peel off the freezer-paper stencil from the T-shirt.

10. Heat-set the paint according to the manufacturer's instructions. I like to iron over the painted area at medium heat for about 20 seconds. This ensures that the T-shirt is washable.

11. Freehand the bird detail embroidery (as Christine did) or use the template as a reference to draw directly onto the fabric with a water-soluble pen. Backstitch all the birds.

12. For the kite, freehand draw the cross lines and kite string or transfer the template lines. Embroider a running stitch over the drawn lines.

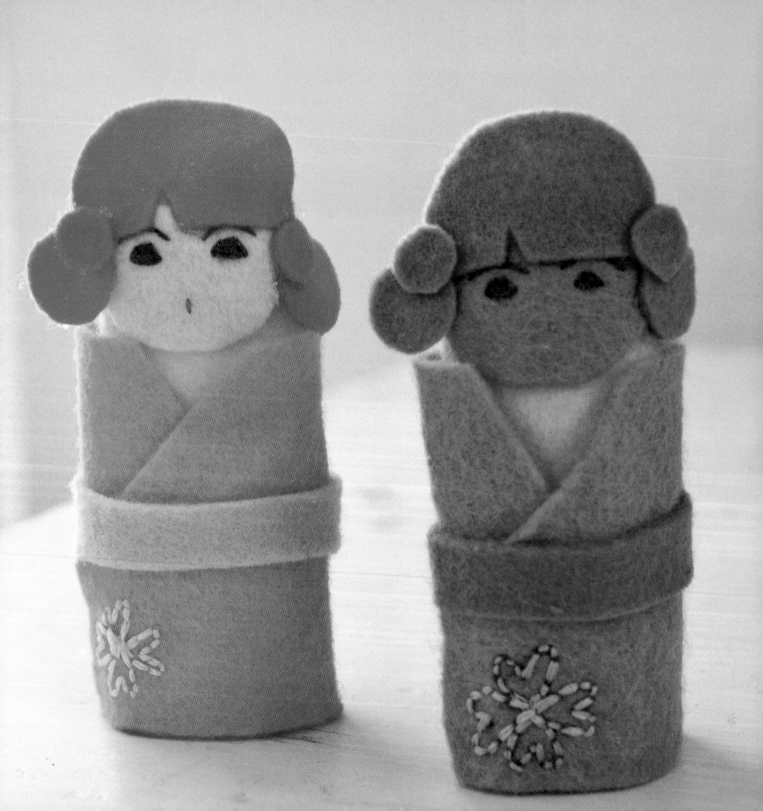

FELT FINGER PUPPETS

PART 1: HANDY THE ROBOT AND SAKURA KOKESHI

MATERIALS

- wool felt scraps in various colors; 5½" × 3" (14 × 7.6 cm) largest needed
- fabric glue
- Handy the Robot and Sakura Kokeshi templates on page 134
- ⅛" (3 mm) hole punch (to punch eyes)
- 7-mm sequins (I used 28 in head band)
- 9-mm sequins (I used 4 in head band)
- 3-mm sequins (I used 16 to make a circle detail on the yellow robot and 5 on the red robot, 3 on his front, 2 on his mouth)

TRANSFER METHOD

- tracing with water-soluble pen (see page 22; If the pen won't show up on felt use permanent marker; cut inside the lines or stitch over them.)
- freehand draw or wax-free transfer paper (see page 23)

THREAD/STITCHES

- cotton embroidery floss in various colors, double and triple strands
- backstitch, blanket stitch, French knot, straight stitch (see pages 136 to 139)

Finger puppets are a fun and easy project to make. Wool felt is one of my favorite things to work with because it's easy to cut, easy to sew, and easy to glue (which means you don't have to sew). I have a thing for robots and kokeshi (a traditional Japanese craft wooden doll), and I thought it would be fun to do versions of both. The red robot was machine- and hand-sewn, and the yellow robot was only hand-sewn. The kokeshi puppets were glue together, and then accents (faces and cherry blossoms on the kimonos) were added with hand stitching. The puppet size allows you to play and try different

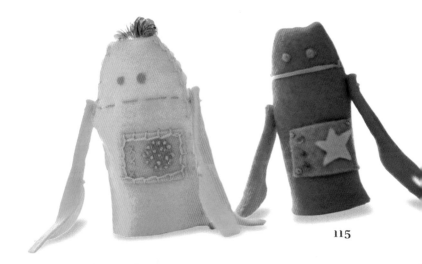

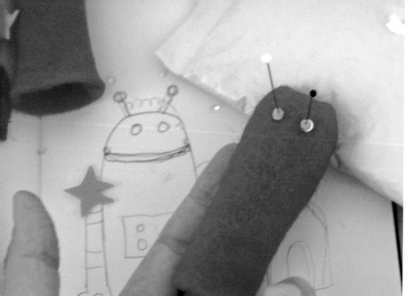

A. *Pin eyes in place while gluing.*

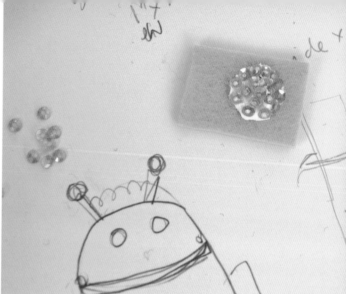

B. *Glue sequins in a circle.*

things. Make a bunch in different colors or add your own accents, such as hats, hairdos, extra arms, or antennae. Sequins, beads, and trim are easy to add to this project as well. Who doesn't want a little razzle-dazzle on their finger puppets?

FOR BOTH PUPPETS

1. Trace the templates and cut out all your pieces. If you traced the templates with permanent marker, cut just inside the lines. Freehand draw or trace the accent designs using wax-free paper on your pieces as needed.

2. Stitch the puppet front and back panels together with a ⅛" (3 mm) seam allowance; turn right side out. Or sew the pieces together with a blanket stitch; no need to turn right side out.

Handy the Robot

1. Cut or punch holes for the eyes; glue in place using pins to secure until dry (see A). Assemble the front panel. Option A: Cut and glue a star, and then attach three sequins on the left side with French knots. Option B: Create a circle of glue and place sequins in the glue (see B). When dry, add French knots in the sequin centers (these add a great detail and help to secure the sequins). Make (approximately) three cross-stitches in contrasting colors on the left.

2. Stitch the mouth with a straight or a running stitch; feel free to accent with sequins or make a different mouth shape.

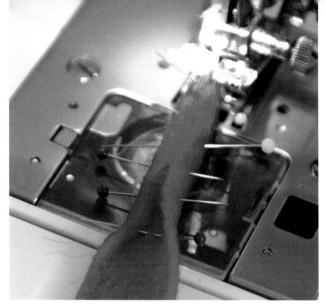

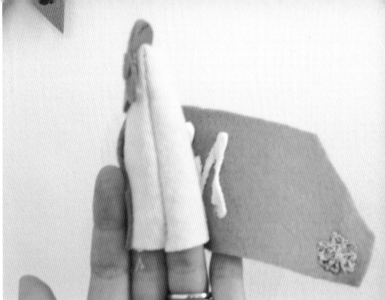

C. *Fold in upper arms and stitch to secure.*

D. *Add glue to secure the kimono to the body.*

3. Fold in the upper arm edges to overlap in the center, making the arms skinnier at the top, and pin. Tack the edges together with a running stitch, or machine-sew (see C). Tack the arms onto the body using French knots.

4. Tack the panels to the body using a blanket stitch or French knots in the corners.

5. Feel free to decorate more; add a star to the back, or a head decoration. For the head decoration I created, thread a needle and pull the needle from the inside through the top of the robot's head. Layer your sequins in order: fourteen 7 mm, four 9 mm, and fourteen 7 mm. Pull the thread back inside of the head and tie off.

Sakura

1. Start by embroidering the face and the flower detail on kimono.

2. Glue hair together, placing the small dots on top of large dots; let dry. Place them at an angle on the main hairpiece and glue.

3. Glue the face onto the body and then glue the hair onto the face.

4. Glue kimono to the body, making sure the flower detail shows on the outside. I found it easier to add glue as I went around the body (see D). Immediately wrap the obi (belt) around the robe about 1" (2.5 cm) from the bottom and have it overlap in the back; glue. The belt helps keep the robe in place as the glue dries. Now that you have all your finger friends, have a puppet show!

ARTIST VERSION: DIGIT AND AIKO

by Wendy Crabb

MATERIALS

- felt scraps, plus a 4" × 2½" (10 × 6 cm) piece for Aiko's dress, and 3" × 3½" (7.5 × 9 cm) piece for Digit's body
- Digit and Aiko templates on page 135
- optional: sewing machine and coordinating thread

TRANSFER METHOD

- tracing with water-soluble pen (see page 22; if pen doesn't show up on felt use permanent marker; cut just inside lines or stitch over them).
- wax-free transfer paper (see page 23) or freehand the design elements with permanent marker or pencil

THREAD/STITCHES

- pearl cotton #8 (for French knots)
- cotton embroidery floss in a double strand for eyes, lightning bolts, and hearts on Digit, and eyes and mouth on Aiko
- backstitch (see page 136)
- blanket stitch (see page 136)
- French knots (see page 137)
- machine-stitch elements with several passes

I immediately thought of Wendy Crabb to make versions of the hand puppets—she's made adorable full-size softies of both robots and kokeshi in the past. I adore how different our versions came out. She designed simple shapes that have ample room to add flair. There's potential for a lot variation on the robot panels and what you put inside them. Simply changing the body color would also change these immensely. I do think our versions would definitely play nice together!

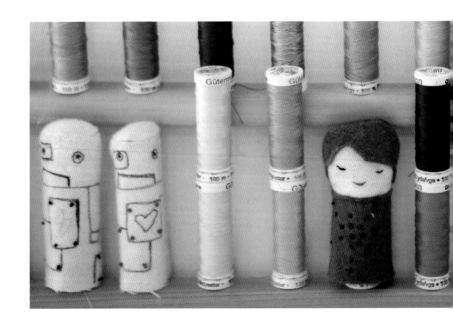

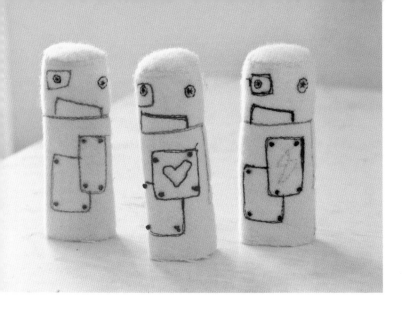

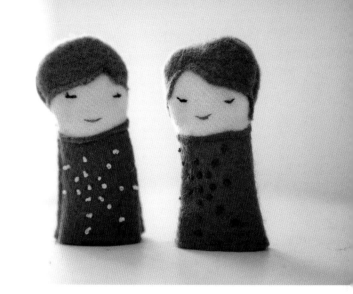

Digit

1. Trace the pattern and then draw freehand or trace the lightening, eyes, nose, etc.

2. Embroider the eyes and panel elements.

3. Hand- or machine-embroider the outer lines of the panels.

4. Add French knots for the corner rivets.

5. Blot with a paper towel moistened with water to remove the fabric-pen markings.

6. With the right sides facing, sew the panels together with a ¼" (6 mm) seam.

7. Turn right side out and attach the top with blanket stitch.

Aiko

1. Trace pattern pieces with a fabric pen and cut out. To make the face easier to sew, cut it a bit outside your lines.

2. Use the machine to sew the front dress to face, hair to face/dress piece, and then the back hair to the back dress.

3. Embroider the eyes. Backstitch the mouth outline and use straight stitches to fill.

4. Add French knots in a starburst pattern on her dress.

5. Blot with a paper towel moistened with water to remove the fabric pen.

6. Place right sides together and line up the hair; sew with a ⅛" (3 mm) seam.

7. Turn your puppet right side out and play.

CHAPTER THREE
FIND INSPIRATION

I've heard people say they don't think it's possible to do anything innovative and inventive with traditional media and materials like embroidery and crochet. Naturally, those of us who use embroidery in our creative process inherently disagree with this idea. And just like knitting and other DIY techniques, it appears as if embroidery is gaining traction as a "rediscovered" media these days. I find it exciting to see how people choose to incorporate embroidery in their practices and seem to be able to constantly discover new approaches. In this gallery section, I've tried to gather the work of a few artists whose embroidery strikes an emotional chord with me. I think it's natural to use thread to talk about connections, to illustrate and draw—because after all thread makes amazing lines, to commemorate and relay personal stories as well as to simply decorate in a way that functions entirely differently than painting, collage, or other art techniques. Each of these artists uses embroidery in a way that highlights its beautiful aesthetic appeal while simultaneously contemporizing it and providing a welcomed conceptual twist.

CLOCKWISE FROM TOP LEFT

Renelde Depuetuer, *Wormhole,* 2008-2010, embroidery with cotton and linen on sackcloth, 20" × 20" (50 × 50 cm)

Eireann Lorsung, *Heimweh,* 2011, collage and embroidery on paper, 7¼" × 7¼" (18.5 × 18.5 cm)

Peter Crawley, *No. 1 Croydon* (detail), 2010, black cotton thread on 420gsm watercolor paper, 23.5" × 16.5" (594 × 420 mm)

Takeshi Iwasaki, *Eiseiearkazaris,* 2009, embroidery on fabric, 16" × 16" (41 × 41 cm)

EIREANN LORSUNG
www.ohbara.com

Eireann Lorsung is interested in the places where different strands of thought cross in her work. She is a talented artist, poet, and theorist, so there is a lot of crossing going on!

I love the idea of finding a snippet of text that means something to you and re-interpreting it with thread. In this piece, Eireann used a favorite quote from Derrida: "a fixed form around which ideas can move" to address the way her ideas interact with artistic materials—with one continually informing the other.

A fixed form, 2011, embroidery and beads on linen with fabric frame, 12" × 9" (30.5 × 23 cm).

Here Eireann used the thread to actually hold her collage elements in place. This series of work is about migration and the contemplation of what/where home is.

Signifier Trouble, 2011, embroidery and found ephemera, 7⅝" × 7⅛" (19.5 × 18.5 cm)

Natural Orders, 3" × 5" (7.5 × 12.5 cm)

RENILDE DEPEUTER
http://at-swim-two-birds.blogsport.com

Renilde Depeuter takes the familiar and elevates it to a whole new level. She utilizes incredibly traditional motifs as well as stitches and foraged materials from thrift stores, but manages to combine and alter them to create intimate objects that feel very *now*. I can't quite get over her color combinations and the precision of her work. She doesn't create work with a precise plan, but instead allows material and process to collide and create new universes.

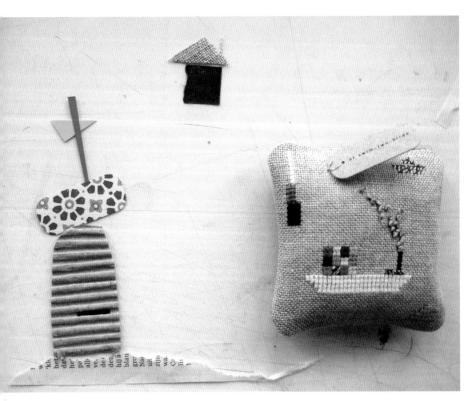

The Sea, 2009, pincushions, embroidery on natural linen with cotton and linen, 3" × 3" (8 × 8 cm)

Wormhole, 2008-2010, embroidery with cotton
and linen on sackcloth, 20" × 20" (50 × 50 cm)

TAKASHI IWASAKI
www.takashiiwasaki.info

These stunningly colorful and playful works are glimpses of imaginary worlds and visions. The shapes and hues collide in ways that feel both personal and proverbial. It would be such great fun to inhabit one of these. I particularly enjoy Takashi's use of bright colors as a means to amplify shapes.

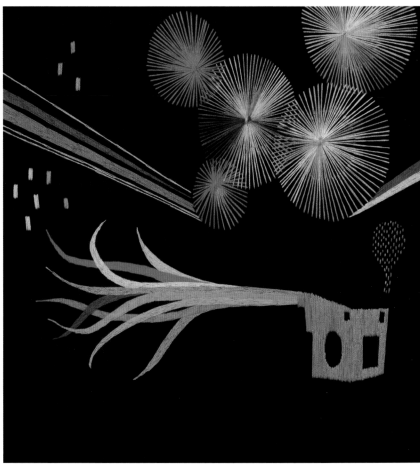

Sakuretsusentaku, 2009, embroidery on fabric, 12" × 12" (30.5 × 30.5 cm)

Noborikyusu, 2008, embroidery on fabric, 10½" × 10½" (27 × 27 cm)

PETER CRAWLEY
www.petercrawley.co.uk

Peter Crawley pares down his work to essentials by using just black thread on thick watercolor paper to render architectural landmarks. Deceptively simple and flawlessly executed, his use of thread enhances our sense of perspective.

BT Tower, 2011, black cotton thread on 420 gsm watercolor paper, 23½" × 16½" (594 × 420 mm)

TEMPLATES

To match the projects in the book, photocopy at 100 percent unless otherwise noted. These templates are provided for personal (noncommercial) use only.

WIPE AND DRY TEMPLATE
Photocopy at 200%

EAT, DRINK, CLEAN TEMPLATE Photocopy at 200%

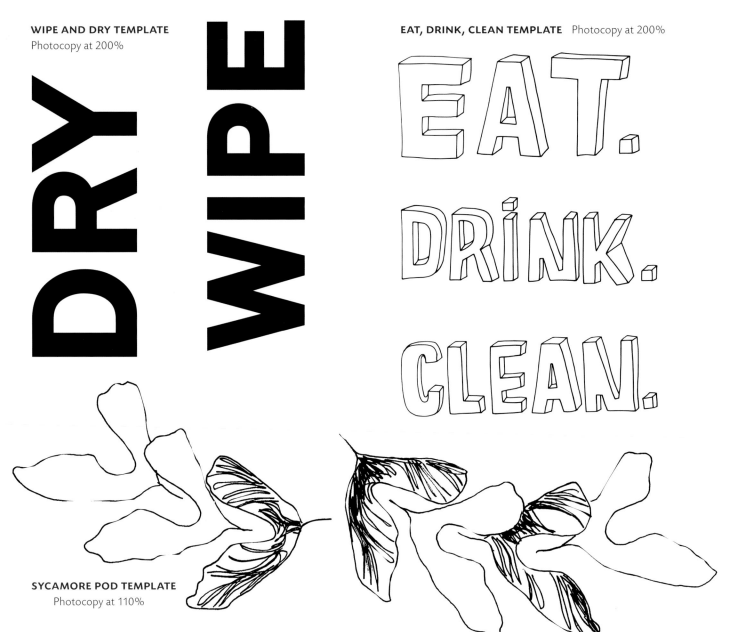

DRY

WIPE

EAT.

DRINK.

CLEAN.

SYCAMORE POD TEMPLATE
Photocopy at 110%

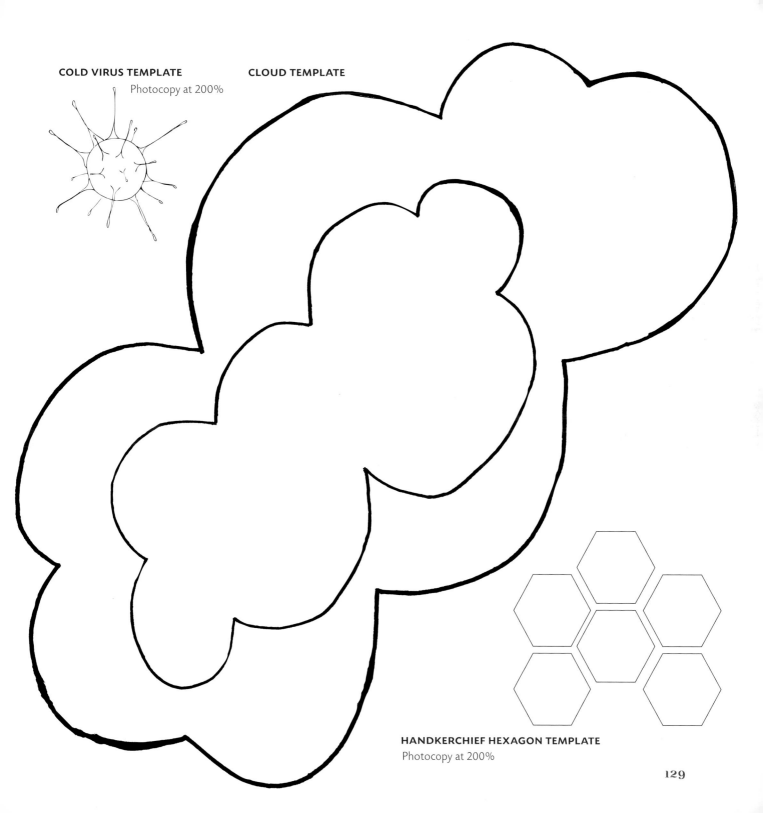

COLD VIRUS TEMPLATE
Photocopy at 200%

CLOUD TEMPLATE

HANDKERCHIEF HEXAGON TEMPLATE
Photocopy at 200%

ARROW TEMPLATE Photocopy at 250%

SCALE TEMPLATE
Photocopy at 200%

FLORAL SILHOUETTE
Photocopy at 200%

SASHIKO FIREWORKS TEMPLATE
 Photocopy at 200%

CAT AND HOUSE TEMPLATE
Photocopy at 200%

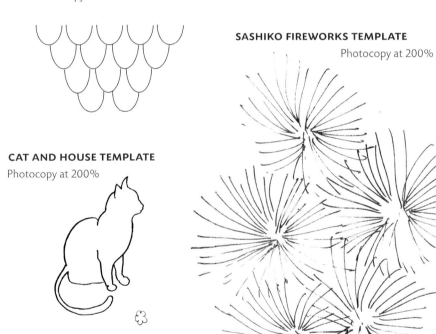

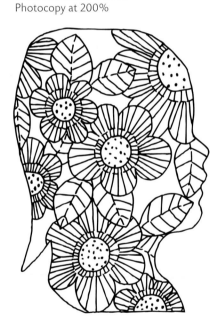

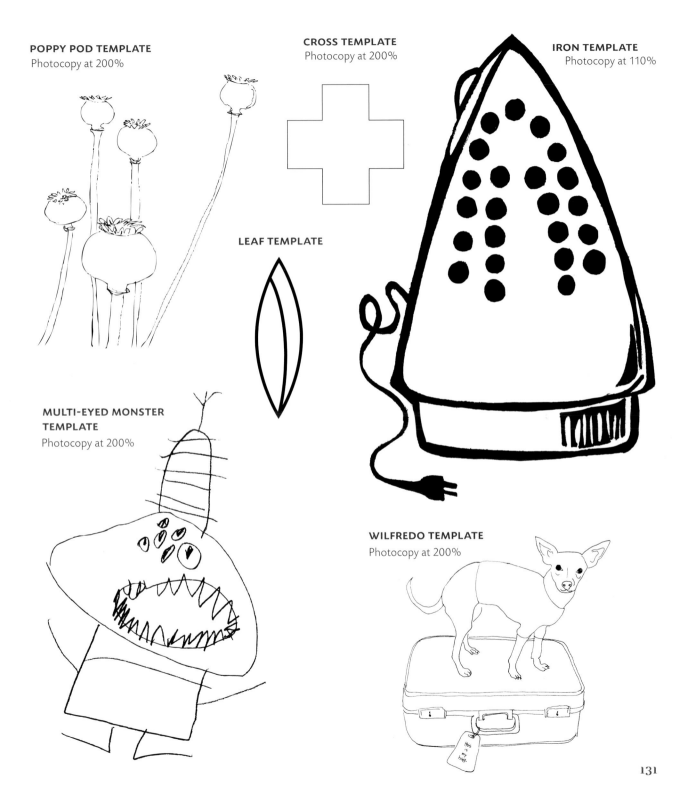

POPPY POD TEMPLATE
Photocopy at 200%

CROSS TEMPLATE
Photocopy at 200%

IRON TEMPLATE
Photocopy at 110%

LEAF TEMPLATE

MULTI-EYED MONSTER TEMPLATE
Photocopy at 200%

WILFREDO TEMPLATE
Photocopy at 200%

131

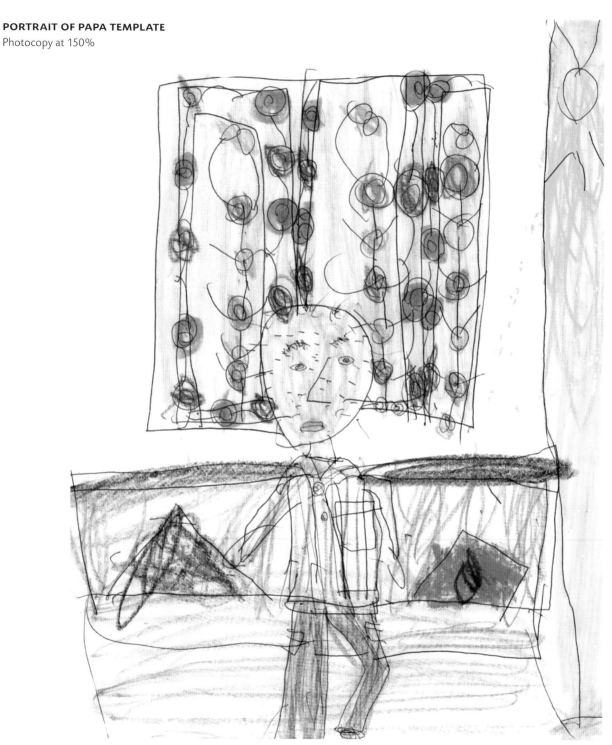

ILLUSTRATIVE PORTAIT TEMPLATE Photocopy at 200%

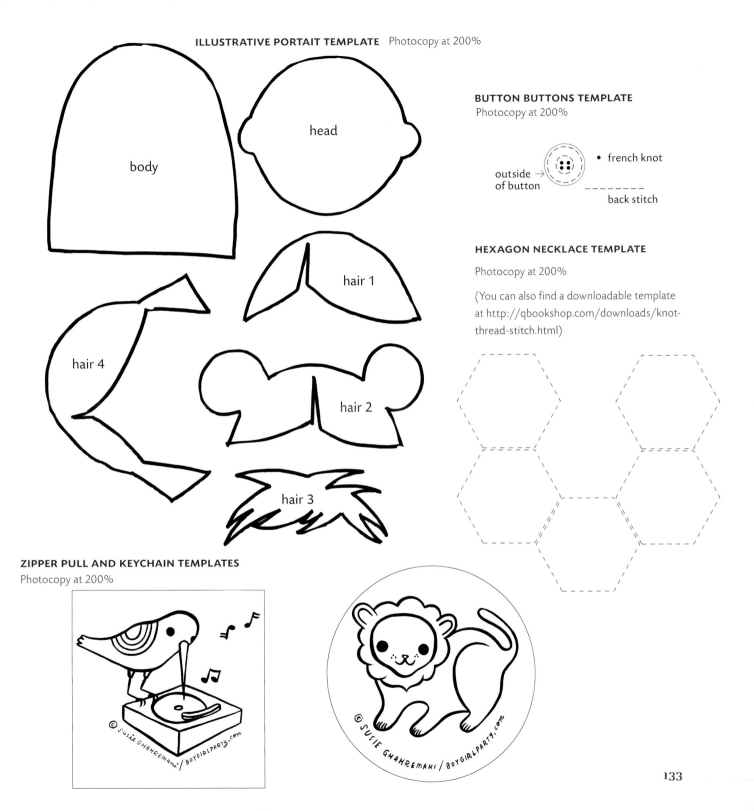

body

head

hair 1

hair 4

hair 2

hair 3

BUTTON BUTTONS TEMPLATE
 Photocopy at 200%

outside →
of button

• french knot

– – – – – – –
back stitch

HEXAGON NECKLACE TEMPLATE

Photocopy at 200%

(You can also find a downloadable template at http://qbookshop.com/downloads/knot-thread-stitch.html)

ZIPPER PULL AND KEYCHAIN TEMPLATES
Photocopy at 200%

© Susie Ghahremani / boygirlparty.com

© Susie Ghahremani / boygirlparty.com

133

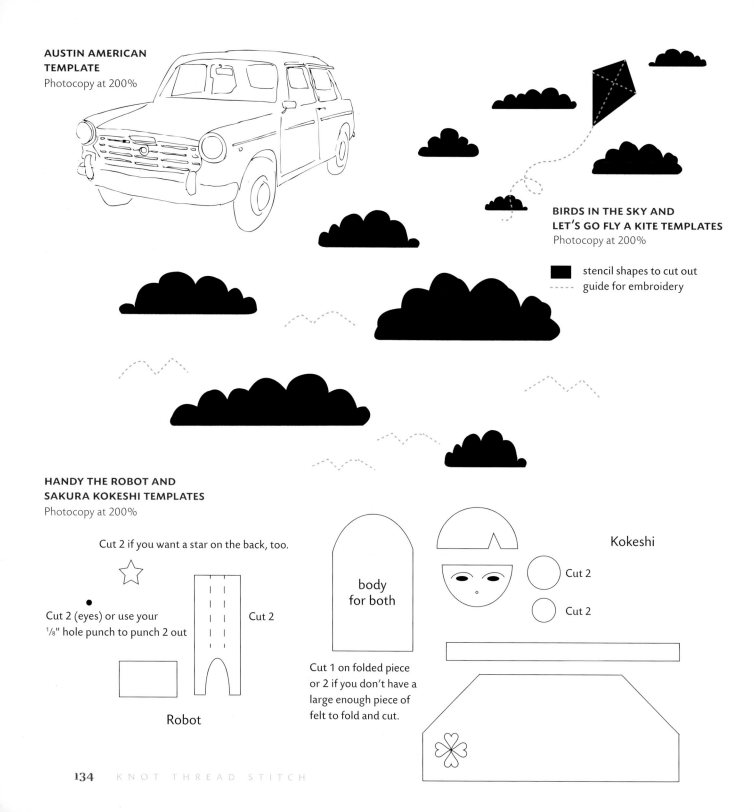

AUSTIN AMERICAN TEMPLATE
Photocopy at 200%

BIRDS IN THE SKY AND LET'S GO FLY A KITE TEMPLATES
Photocopy at 200%

stencil shapes to cut out
guide for embroidery

HANDY THE ROBOT AND SAKURA KOKESHI TEMPLATES
Photocopy at 200%

Cut 2 if you want a star on the back, too.

Cut 2 (eyes) or use your 1/8" hole punch to punch 2 out

Cut 2

Robot

body for both

Cut 1 on folded piece or 2 if you don't have a large enough piece of felt to fold and cut.

Kokeshi

Cut 2

Cut 2

DIGIT AND AIKO TEMPLATES
Photocopy at 200%

cut 1 cut 1

Digit

 cut 1 cut 1

Aiko

dress
front

cut 1

dress
back

cut 2

hair front
cut 1

hair back
cut 1

FRUIT AND VEGGIE CROSS-STITCH

Apple

Corn

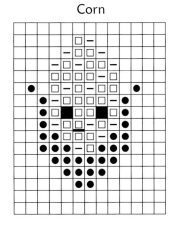

⊠ Apple = red; pear = coral

■ Black

◯ Light green

● Medium green

G Dark green

— Light yellow

□ Corn = yellow; pineapple = gold

▪ Brown

Use black for mouth outlines.

Pear

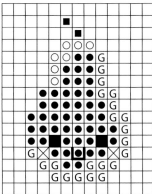

Pineapple*

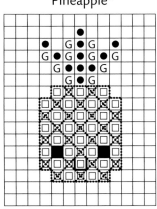

*Use brown for pineapple
outline and diagonal lines.

135

STITCH GUIDE

Don't be afraid to experiment by varying your threads or stitch length. Try combining stitches such as a detached chain stitch with a French knot. When embroidering, consider how tight you want your stitches to be. Every stitch can be made large or small, tightly or loosely, neatly or messy, and will have very different visual effects. This is part of the joy of the process.

BACKSTITCH, LONG BACKSTITCH

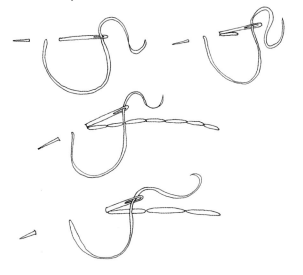

BLANKET STITCH

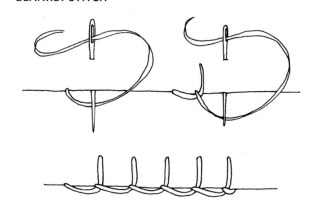

COUCHING

How about couching chains, trim, ribbon, etc.?

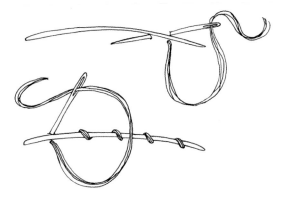

BLINDSTITCH

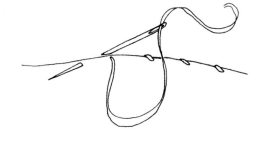

CHAIN STITCH

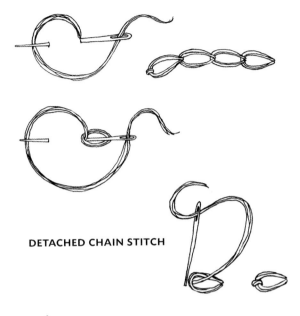

DETACHED CHAIN STITCH

OPEN DETACHED CHAIN STITCH

CROSS-STITCH

Visualize a square and stitch in the corners.

MODIFIED HONEYCOMB STITCH

Stich a row of diagonal lines, then work back stitching perpendicular lines.

FRENCH KNOT

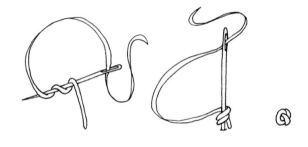

QUILTER'S KNOT

Pinch wrapped threads between your fingers and pull needle through.

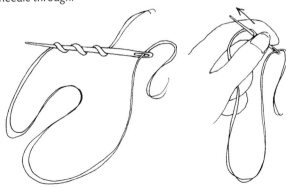

OUTLINE STITCH

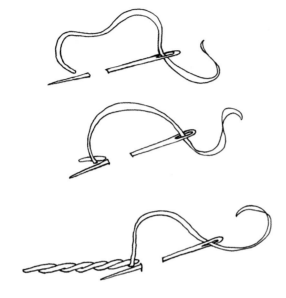

SPLIT STITCH

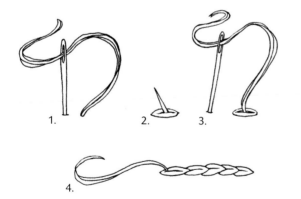

1. 2. 3.

4.

RUNNING STITCH

SASHIKO

Work horizontal and vertical rows first.

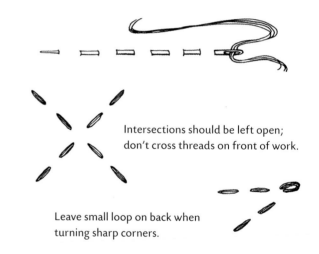

Intersections should be left open;
don't cross threads on front of work.

Leave small loop on back when
turning sharp corners.

SEED STITCH

STRAIGHT STITCH AND VARIATIONS

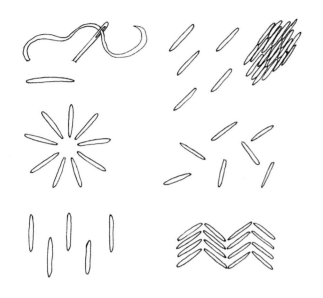

TURKEY STITCH

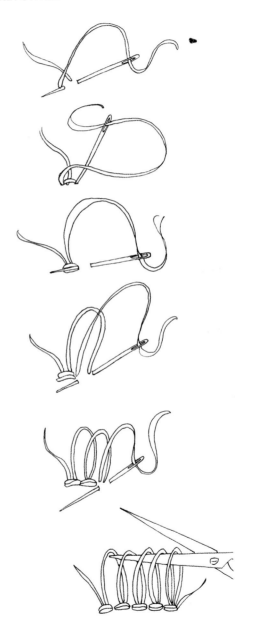

WHIPSTITCH

Push eye of needle under stitch.

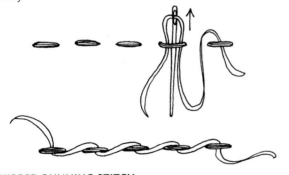

WHIPPED RUNNING STITCH

WHIPPED BACKSTITCH

CONTRIBUTING ARTISTS

Kate Bingaman Burt
www.katebingamanburt.com

Lisa Congdon
www.lisacongdon.com

Andrea Corrona and Ezra Jenkins
hulaseventy.blogspot.com

Wendy Crabb
www.greengirlart.com

Camilla Engman
www.camillaengman.com

**The Frosted Pumpkin Stitchery:
Ashleigh Giberson and Amanda Jennings**
www.thefrostedpumpkinstitchery.com

Susie Ghahremani
www.boygirlparty.com

Christine Hughes
www.darlingstudio.com

Heather Smith Jones
www.heathersmithjones.com

Amy Karol and Delia Jean Matern
www.amykarol.com

Martha McQuade
www.mwmworkbook.com

Sally J. Shim
www.sallyjshim.com

Blair C. Stocker
blairpeter.typepad.com

Betsy Thompson
www.betsythompsonstudio.com

Patricia Zapata
www.alittlehut.com

RESOURCES

Art Supplies

Dick Blick Art Materials: for paint, paper, blending markers, ink, fabric medium, and more
www.dickblick.com

Ultrecht Art Supplies: for paint, paper, blending markers, ink, fabric medium, and more
www.utrechtart.com

Craft and Needlework Supplies

The Beadin' Path: Amazing beads and great jewelry findings
www.beadinpath.com

Cartwright's: Sequins and vintage buttons
www.ccartwright.com

JoAnn's: Floss bobbins, transfer pens, notions, embroidery hoops, etc.
www.joann.com

Lacis: One of my favorite places to shop; books, needlework supplies, scissors, sashiko supplies, threads, and laces
www.lacis.com

M & J Trimming: Sequins and more
www.mjtrim.com

Michaels: Permanent markers, shrink plastic, glue, and jewelry findings
www.michaels.com

Purl Soho: Needlework supplies and great fabrics
www.purlsoho.com

Sashiko Designs: Traditional sashiko supplies
www.sashikodesigns.com

Embroidery Blanks

Discount Embroidery Blanks: handkerchiefs, tea towels, and buttons to cover
www.discountembroideryblanks.com

Felt, Felt, and More Felt

A Child's Dream Come True: Top-of-the-line wool felt, natural crafts, toys, and more
www.achildsdream.com

Erica's: Felt and felt balls
www.ericas.com

Giant Dwarf: felt
www.etsy.com/shop/giantdwarf

Gifted Lamb Secret: felt balls
www.etsy.com/shop/GiftedLambSecret

Framing

IKEA: Inexpensive frames
www.IKEA.com

FramTek: Framing spacers and supplies
www.frametek.com

Michaels: Frames and supplies www.michaels.com

Pillow Inserts

Robey's: Pillow inserts, eco-insert option, and custom sizes
www.wholesalepillowinserts.com

Tea Towels

abigail*ryan homewares: Printed tea towels and more
www.abigailryan.com

Third Drawer Down: Limited edition textiles, bed linens, and more
www.thirddrawerdown.com

ABOUT THE AUTHOR

Lisa Solomon is a studio artist who moonlights as a college professor and graphic designer. Profoundly interested in the idea of hybridization (sparked from her Happa heritage), Solomon's mixed-media works and installations revolve thematically around domesticity, craft, and triggers that may be construed as masculine and/or feminine. She is drawn to found objects, tending to alter them conceptually so their meanings and original uses or intents are repurposed. She often fuses "wrong" things together—recontextualizing their original purposes and incorporating materials that question the line between art and craft. She received her BA in art in 1995 from UC Berkeley and her MFA from Mills College in 2003. She has exhibited and works with galleries both nationally and internationally, is in numerous private and public collections, and is continually tweaking artworks in her backyard studio. She resides in

Oakland, California, with her husband, daughter, a three-legged cat, a deaf French bulldog, a pit-bull, and many, many spools of thread.

www.lisasolomon.com

ACKNOWLEDGMENTS

To Mary Ann Hall: I can't believe you convinced me to do this—but am so incredibly grateful you did! Thank you for talking me through everything, for your continuous help and answering of my ridiculous rookie questions, for making me feel supported and competent (even when clearly I wasn't). You have an open invitation to visit, and I promise a tea-leaf salad when you do (even though you can now make your own). I hope that even though this book is complete, we will occasionally tell one another what we are having for dinner.

To Andrew Paytner: Thank you for your vision, eye, talent, and speed! (Fastest photo shoots ever?). Really, you get what I do, and I adore your photos (even the ones of me—which NEVER happens).

To Marla Stefanelli: Thank goodness for your amazing expertise and your incredible illustration skills. It was a relief to have such a pro looking over everything.

To everyone at Quarry who worked on the book: Thank you for helping me realize my vision and for not killing me when I asked for yet another scripty font.

To all the amazing contributors in this book: I am simply speechless. You all wow me and have been inspirational to me for such a long time. What an absolute treat to be able to work with you and a distinct honor to call you friends. To have your work

and mine collected together here in this very real BOOK is something I can't quite believe really happened. I am so touched that you each took the time to make such beautiful contributions. A million times over; thank you!

To my parents: In many ways this book could not have happened without you. You helped me so much with childcare, but more importantly for the emotional support. You have always wholeheartedly supported me in my endeavors, and this was no exception. I'm so, so lucky to have parents like you. I can count on you for anything—and bask when you are proud of me.

To my dear friends and fellow artists, crafters, and bloggers: Your kindness, interest, and support of what I do means more than I know how to express. Thank you for being out there and for all the encouragement. And to those of you that knew about this project and spurred me on—I'm so grateful for your confidence, enthusiasm, your gentle asking of how it was going, and your reassurances that I could do it.

To my husband: I am who I am because I am with you. You have this wonderful way of keeping our house going. But really it's more than that—you make it a *home*—and that is of such utter importance, I can't properly express my gratitude. Thank you for helping me follow my whims and dreams.

DON'T MISS THESE OTHER TITLES FROM QUARRY BOOKS!

Hand Spun
Lexi Boeger
978-1-59253-762-4

Unfurling, A Mixed-Media Workshop with Misty Mawn
Misty Mawn
978-1-59253-688-7

Creative Pilgrimage
Jenny Doh
978-1-59253-753-2

Creative Paint Workshop for Mixed-Media Artists
Ann Baldwin
978-1-59253-747-1

Drawn In
Julia Rothman
978-1-59253-694-8

Water Paper Paint
Heather Smith Jones
978-1-59253-655-9

PHOTO CREDITS

Camilla Engman: page 90

Kristen Loken: page 104

Lisa Solomon:
page 26 (top left); page 30 (right); page 31; page 33 (left); page 35; page 39 (bottom); page 41; page 44; page 48 (left); page 58; page 59 (left); page 61; page 66; page 72; page 75 (right); page 82 (bottom); page 83; page 88; page 89; page 94; page 99; page 100; page 101 (top); page 105; page 106; page 110; page 111; page 114; page 116; page 117; page 119 (left)

Gallery images: Courtesy of the artists: page 120; page 123 through 127